IMPERIAL MUGHAL PAINTING

IMPERIAL MUGHAL PAINTING

STUART CARY WELCH

George Braziller New York

Published in 1978.

For information address the publisher:
George Braziller, Inc.,
One Park Avenue, New York, New York 10016

Library of Congress Cataloging in Publication Data
Welch, Stuart Cary.
 Imperial Mughal painting.
 Bibliography: p.
 1. Illumination of books and manuscripts, Mogul.
2. Miniature painting, Mogul. I. Title.
ND3247.W44 745.6′7′0954 77-4049
ISBN 0-8076-0870-X
ISBN 0-8076-0871-8 pbk.

First Edition

Printed by Imprimeries Réunies in Switzerland
Designed by DIANE KOSOWSKI

Contents

Acknowledgments

This book would be less interesting and useful without the help of many friends and colleagues. For historical and literary information I am especially grateful to Annemarie Schimmel, Martin B. Dickson, and Wheeler Thackston, who also translated numerous passages of Persian and identified several baffling subjects of pictures. Brian Silver most generously and insightfully translated the Urdu Ghazals of Bahadur Shan II quoted in the Commentary to Plate 40. As usual, I am beholden to Mr. and Mrs. W. G. Archer, Richard Ettinghausen, Ralph Pinder-Wilson, Norah Titley, Robert Skelton, and Pramod Chandra, for information both published and by word of mouth. Esin Atil, Milo Beach, Toby Falk, Ellen Smart, Mark Zebrowski, Sheila Canby, and Joyce Paulsen have also been most kind in offering help, as have Marie Swietochowski and Daniel Walker. I am especially grateful to Seymour Slive of the Fogg Art Museum; Joan Lancaster of the India Office Library; John Irwin and Helen Angus of the Victoria and Albert Museum; Dr. G. Marrison, Ernest Anderson and K.J. Ames of the British Library; Ann Walsh, A.C. Butler, and J.G. Burton-Page of the School of Oriental and African Studies at the University of London; Dr. Manfred Kramer of Akademische Druck-u. Verlagsanstalt; R.A. May and Rosemary McKendrick of The Bodleian Library; P. Henchy of The Chester Beatty Library; Marie Lawrence of The India Office Library and Records; Fredd Gordon of The Metropolitan Museum of Art; Carl Nödl of the Österreichisches Museum für angewandte Kunst; Judy J. Roland and Betty L. Zimmerman of The Cincinnati Art Museum; Jan Fontein of the Museum of Fine Arts, Boston; as well as the late Harold P. Stern and Thomas Lawton of the Freer Gallery of Art for permission to reproduce masterpieces from their collections.

I would also like to add a special word of thanks to the staff at George Braziller, in particular, Adele Westbrook and Priscilla Truman, for their enthusiasm and combined efforts on behalf of this book.

The author and publishers would like to express their sincere thanks to the following institutions and individuals who kindly provided materials and granted permission to reproduce them in this volume.

Color Plates

Boston, Courtesy Museum of Fine Arts, Francis Bartlett Donation of 1912 and Picture Fund, Plates 16, 17, 20; Purchased, Arthur Mason Knapp Fund, Plate 39.

Cambridge, Fogg Museum of Art, Plates 24, 26, 29, 33, 34, 35, 37, 40 (Photo, Michael A. Nedzweski).

Cincinnati, Cincinnati Art Museum, Gift of John J. Emery, Plate 15.

Dublin, Courtesy of The Chester Beatty Library and Gallery of Oriental Art, Plates 28, 36, 38 (Photo, Pieterse Davison International Ltd., Dublin).

London, The British Library, Reproduced by permission of The British Library Board, Plates 11, 18.

London, The British Museum, Plates 5, 6, 19 (Photo, A.C. Cooper Ltd., London).

London, India Office Library and Records, Foreign and Commonwealth Office, Plate 25.

London, School of Oriental and African Studies (University of London), Plate 4.

London, Victoria and Albert Museum, Plates 7, 12, 13, 14, 27 (Photo, A.C. Cooper Ltd., London).

New York, The Metropolitan Museum of Art, Gift of Edward C. Moore, Jr., 1928, Plate 10; Purchase, 1955, The Kevorkian Foundation supplementing The Rogers Fund, Plate 30.

Oxford, Courtesy of the Curators of the Bodleian Library, Oxford, Plates 8, 23.

Vienna, Österreichisches Museum für angewandte Kunst, Plates 1, 2, 3 (Photo, Akademische Druck-u. Verlagsanstalt from their *Hamza-Nama* facsimile edition).

Washington, Courtesy of the Smithsonian Institution, Freer Gallery of Art, Washington, D.C., Plates 9, 21, 22, 31, 32.

Black-and-White Figures

Boston, Courtesy Museum of Fine Arts, Francis Bartlett Donation of 1912 and Picture Fund, Figure V.

Cambridge, Fogg Museum of Art, Figures III, IV.

London, The British Museum, Figure I.

London, Victoria and Albert Museum, Figure II.

Foreword

Mughal patrons and artists doted on the world and its inhabitants. No pains were spared to record them realistically in life-oriented pictures mostly of people and animals. The people are exceptional—some of mankind's quirkiest worldlings and wisest saints, shown in depth, to be scrutinized inside and out, if necessary with a magnifying glass.

All the pictures published here were made for the Mughal emperors or their immediate families. Like the richest cream at the top of the milk, they are intense essences of their culture, to be savored slowly and completely. Everyone can enjoy their virtuosity and naturalism; but the more one learns about Mughal historical and cultural background, the more nourishing the paintings. In this book, I have tried to open wide the Mughal door.

Introduction

Babur (1526–1530)

The founder of the Mughal dynasty in India, Zahir-ud-din Muhammad Babur, a Muslim of the Sunni sect, was descended on his father's side from Timur (Tamerlane) and from Chinghiz Khan on his mother's. He was born in Ferghana (now in Soviet Turkestan) in 1483. When he was scarcely twelve years old, his father was accidentally killed by falling from a pigeon tower. At fourteen his will to carve out a kingdom was set. The dynamic and adventurous young prince forsook Ferghana and led his followers unsuccessfully against Samarkand. After a time of wandering, he won back Ferghana in 1498, and in 1500–1501 he captured Samarkand, which he soon lost to the Uzbeks. His first major success came in 1504, when he captured Kabul and Ghazna, from which he made frequent military forays in the years ahead. Always eager, he led five expeditions through the vulnerable passes of the northwest into Hindustan (northwestern India) between 1519 and 1525, when he crossed the border for the last time, at the head of ten thousand men.

In 1526, his cavalry and artillery defeated the Muslim Sultan of Delhi and the Hindu Raja of Gwalior at Panipat, near Delhi. At Kanhua, a year later, he overwhelmed the combined armies of the remaining Rajput (Hindu) princes, thereby gaining a secure hold on Hindustan. Although Arab, Turkish, and Iranian Muslims had come to India, some to establish dynasties, since the seventh century A.D., Babur's became the greatest Muslim power in Indian history. Always a warrior, his expansionist policies continued until his final illness in 1530, when he named as heir his son Humayun. Ironically, Babur disliked India and never adjusted to its climate and customs. His remains were buried at Kabul, where Shah Jahan built him a mausoleum in 1646.

Although no works of art can be associated with Babur as patron, his extraordinarily lively autobiography, (the *Waqi 'at-i-Baburi*, written in Chaghatai Turkish and translated into Persian as the *Babur-Nameh*) reveals his mentality so fully that from it we can imagine how they might have looked. Like his descendants, Babur was deeply concerned with people and nature. His book abounds in vividly insightful descriptions of mankind as well as flora and fauna. Although he was happiest writing prose, his ideas are those of a poet and scientist, a seemingly paradoxical mixture that set the mood for future Mughal art. While the miniature paintings of his Persian forebears can be described as visual equivalents to rhymed verse, views of the world in arabesque, a new concern with naturalism was infused into the tradition by the Mughals, whose pictures are closer to prose.

The Technique of Mughal Miniature Painting

Miniature painters sat on the ground while working, with one knee flexed to support a drawing board. (Plate 19). Their technique was deceptively simple: opaque watercolor on paper or occasionally on cotton cloth. Artists learned the trade secrets of their ateliers as apprentices, often from fathers or uncles, as this craft was frequently a family occupation. As children, they were taught how to make balanced, finger-fitting paintbrushes of bird quills set with fine hairs plucked from kittens or baby squirrels. They also learned how to grind mineral pigments, such as malachite (green) and lapis lazuli (blue), in a mortar; how to sort them grain by grain according to purity and brilliance; and how to prepare the aqueous binding medium of gum arabic or glue. Other pigments were made from earths, insect and animal matters, and metals.

To make metallic pigments, gold, silver, and copper were pounded into foil between sheets of leather, after which the foil was ground with rough salt in a mortar. The salt was then washed out with water, leaving behind the pure metal powder. For a cool yellow gold, silver was mixed with it; for a warmer hue, copper was added. Because such pigments as copper oxide were corrosive, the paper was protected from them by a special coating. Some artists, such as Basawan (Plates 6, 8, 12, 13) were particularly admired for their manipulation of gold—which they pricked with a stylus to make it glitter—burnished, or modelled by tinted washes.

Although artists did not make paper, they were connoisseurs of its qualities. Composed of cloth fibres, it varied greatly in thickness, smoothness, and fineness. Akbar's painters of the late sixteenth century preferred highly polished, hard, and creamy papers, while Shah Jahan's artists employed thin, extremely luxurious sorts, possibly made from silk fibres.

A complex, very costly series of steps involving many people was required to make a Mughal painting. Pictorial ideas usually began with the patron, who summoned the appropriate artist (or artists) to carry them out. Several of the most renowned Mughal artists were specialists, such as Govardhan, who was noted for portraits of saints, musicians, and holy men (Plate 24), or Mansur, famed for birds and animals (Plates 26–27). After the painter and patron had conferred, sketches, such as Figure V, were prepared. In this instance, the artist drew from life, which lent his sketch disturbing immediacy. Like others of the sort, it was intended not for the patron but for the workshop, as a model from which to paint, and it did not have to be formal and tidy. Mistakes were scumbled over in white pigment and redrawn.

Later, in the artist's studio, the drawing would either be copied or pounced (traced) onto the thicker paper or cardboard of the finished work (Figure V, Plate 23). Tracing was done with a piece of transparent gazelle skin, placed on top of the drawing, the contours of which were then pricked. It was then placed on fresh paper, and black pigment was forced through the pinholes, leaving soft, dark outlines to be reinforced and clarified by

brush drawing. Sometimes, the original drawing included notations of colors, in words or washes of pigment.

Unfinished paintings reveal the progress from bare paper to thin outlining in black or reddish brown ink and to the many stages of coloring, which was built up layer by layer to enamel-like thickness. Usually, gold highlights were the last step before burnishing. Burnishing was done by laying the miniature upside down on a hard smooth surface and gently but firmly stroking it with a polished agate or crystal, a process comparable to varnishing an oil painting, which provided protective hardening and gave an overall unity of texture.

The length of time it took to accomplish all this varied according to the painting and period when it was done. Robert Skelton and Ellen Smart discovered a small marginal inscription on an illustration to the *Babur-Nameh* stating that Ram Das worked on it for fifty days (see Figure II). Other paintings published here must have taken considerably longer. After the artist had finished his picture and shown it to the patron, who had probably overseen its progress step by step, it was turned over to other specialists to be trimmed, mounted on splendidly illuminated borders, and bound into a book or album, according to imperial wishes. Occasionally, pictures were mounted on walls (Plate 17).

The social position of artists varied greatly. Akbar himself learned to paint as a child; and some of the artists were aristocratic courtiers who also served in diplomatic or other governmental capacities. Most court painters, however, were revered but humble craftsmen, whose talents had earned them privileged positions near the throne. A few, such as Jahangir's favorite artist, Abu'l Hasan, who was honored with the title "Wonder of the Age," grew up in the royal household.

Paradoxically, the lot of artists was often more secure, and probably happier, than that of princes. Artists painted on and on, from one reign to the next, while royalty rose to dizzy pinnacles of wealth and power, too often only to be imprisoned or murdered. Since all but a few Mughal rulers were keenly interested in painting, artists were generously rewarded. Salaries must have been ample, and when a patron was especially pleased, presents were lavish. Bichitr painted himself in the foreground of a picture (Plate 22) holding a miniature of an elephant and a horse, gifts no doubt from Jahangir.

Nassir-ud-din Muhammad Humayun (1530–1556)

The first documented patron of Mughal painting, Humayun, was a puzzling and intriguing figure. An inheritor rather than a founder, albeit of a flimsy empire, he was less charismatic than his father, more formal and reserved, gentler, and more concerned with protocol. But he was also a gifted general on occasion, as when he defeated Bahadur Shah in Gujarat in 1535.

Characteristically, however, he lapsed into triumphant pleasure at Agra

instead of pushing ahead. Wine, opium, and ease were Humayun's (and his dynasty's) temptations. Much energy was also expended directing highly complicated astrological schemes. He commissioned a huge tent, with compartments for each month, where his courtiers could gather according to astrological signs. He also possessed a large carpet with nine astrological circles, each named after a star, where courtiers stood according to rank. When his son Akbar was born, astrologers gave a reading so favorable that he danced for joy.

His own horoscope was less auspicious. For kindly, gentlemanly Humayun's reign was usually ill-fated. His brothers, Hindal Mirza and Kamran, were constant threats; worse still were the Afghans, led by Sher Khan, an erstwhile noble of Babur's who seized Bengal and challenged Humayun for the rest of Hindustan. After driving Humayun back to Agra in 1539, the Afghan chief assumed the title of Sher Shah. As dynamic and ambitious as Humayun was fatalistic and dormant, Sher Shah forced the Mughal emperor to flee towards the Punjab, after a second defeat at Bilgram. At this critical moment, Mirza Kamran—dependably nasty—blocked off the Punjab and Kabul, forcing Humayun into Sind, where Akbar was born in 1542. After two years of miserable wandering, Humayun was given refuge in Iran by the Safavi ruler, Shah Tahmasp.

The Shah's generosity to Humayun was probably motivated by politics and religion. As a Shiah Muslim threatened by Sunni powers (the Ottomans to the West, the Uzbeks to the East), he was keen to gain a strong Shiah ally by converting the Mughal emperor to his sect. To secure military and economic support for his reconquest of Hindustan, Humayun probably met the Shah's terms. Aided by the Safavis in 1545, he captured Qandahar, the strategic fortress at the gateway to India which remained a bone of contention between Safavis and Mughals (Plate 33). Although he had agreed to return it to the Safavis, after garrisoning Qandahar, Humayun moved on to Kabul, which he captured from Mirza Kamran. As this brother persisted in his treachery, Humayun blinded him at the insistence of his nobles in 1553.

Two years later, when the Afghan power had broken down in India following Sher Shah's death, Humayun reoccupied Agra and Delhi. Seven months later, he tripped on the stairway of Sher Shah's library and fell to his death. Humayun's twenty-five year reign, ten of it spent in exile, left the Mughal empire scarcely stronger than it had been at the death of Babur.

Humayun's visit to the Safavi court in 1544 was as crucial to art history as to the empire. While there, he admired the brilliant paintings by Shah Tahmasp's artists (see Welch, *Persian Painting*, Braziller, 1976, especially Plates 1, 19, 28, 29). By happenstance, Shah Tahmasp's inspiring patronage of painting was then being replaced by more "responsible" interests, and in 1546 Humayun was able to summon two Safavi artists to join his court. These were Mir Sayyid 'Ali, whose artist father Mir Musavvir followed later, and Abd us-Samad, both of whom left Tabriz along with a bookbinder and a

mathematician in the summer of 1548. They first went to Qandahar, where they waited for a year while Humayun fought Kamran, until a lull in the war enabled Humayun to have them escorted to Kabul. They arrived there in November 1549 and were kept busy until the march to Hindustan five years later, in November of 1554.

Humayun's choice of Abd us-Samad and especially Mir Sayyid 'Ali was consistent with the tendencies to naturalism already apparent in Babur's prose. Of all Shah Tahmasp's artists, Mir Sayyid 'Ali was the sharpest and most accurate observer, sparing no pains to record the precise shape and texture of fur or metal or the odd bumps of a nose. He was also a brilliant designer of arabesque, who shared his father's genius for abstracting figures into stunningly ornamental patterns. Unfortunately, the Mir's artistic wizardry was accompanied by a moody and suspicious temperament.

Less gifted, but far more flexible and adaptable was Abd us-Samad, whose Mughal phase was far longer and more productive. Paintings by him from the Kabul period reveal that he soon began to adjust his Safavi style to conform to the growing Mughal desire for accurate portraiture and anecdotal reportage.

Although it is unsigned, damaged, and considerably repainted, *The House of Timur* (Figure I) can be recognized as Abd us-Samad's work at Kabul or in India just after the return. Grand in scale, sumptuous in color, and a total reflection of Humayun's royal taste, this picture on cotton is the major monument of early Mughal art. Apparently, it continued to be highly regarded, for it was brought up to date by the addition of portraits of three generations of Humayun's heirs.

Abu'l Fath Jalal-ud-din Muhammad Akbar (1556–1605)

Without Akbar, the Mughal empire and its art would be known only to specialists. The empire's re-founder, he was one of India's wisest and mightiest rulers, whose energy and inspiration sparked his followers to peak performances. When Humayun died, Prince Akbar, although not yet fourteen, was already soldiering in the field, having been sent to the mountains with an army to expel the ex-king, Sikander Shah Afghan. Bairam Khan, one of his father's ablest generals, improvised a throne on which the boy began his reign. Later, as regent, Bairam Khan brought stability to the shaky kingdom and enabled the young ruler to grow with some degree of tranquility. But Akbar resented domination, even at fourteen. Physically dynamic and adventurous in spirit, he balked at many of the subjects usually taught princes, so preferring hunting and wrestling to reading that he remained illiterate. His son, Jahangir, reminisced that Akbar "always associated with the learned of every creed and religion . . . and so much became clear to him through constant intercourse with the learned and the wise . . . that no one knew him to be illiterate, and he was so well acquainted with the niceties of verse and prose composition that this deficiency was not thought of." Jahangir's lively

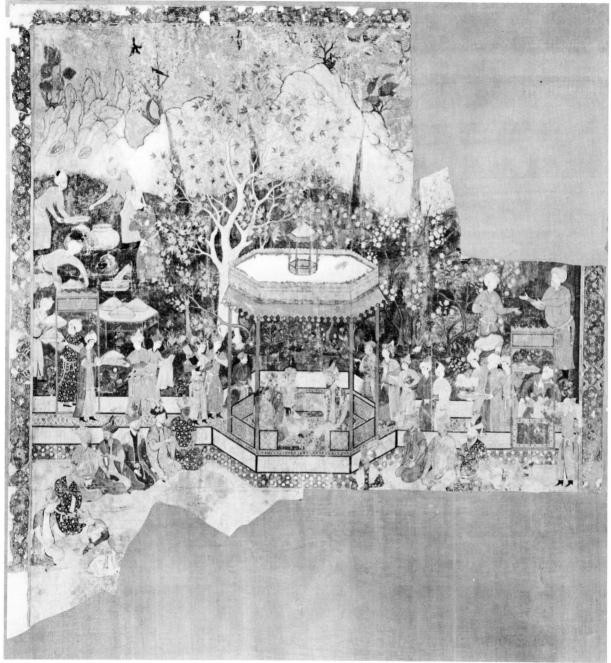

I

portrait continues, ". . . he was of middle height, but inclined to be tall; he was of the hue of wheat; his eyes and eyebrows were black, and his complexion rather dark than fair; he was lion-bodied, with a broad chest, and his hands and arms long. On the left side of his nose, he had a fleshy mole, very agreeable in appearance, of the size of half a pea. Those skilled in the science of physiognomy considered this mole a sign of great prosperity and exceeding good fortune. His august voice was very loud, and in speaking and explaining had a peculiar richness. In his actions and movements he was not

like the people of the world, and the glory of God manifested itself in him. Notwithstanding his kingship, his treasures, and his buried wealth past computation, his fighting elephants and Arab horses, he never by a hair's breadth placed his foot beyond the base of humility before the throne of God, and never for one moment forgot Him. He associated with the good of every race and creed and persuasion, and he was gracious to all in accordance with their condition and understanding. He passed his nights in wakefulness, and slept little in the day; the length of his sleep during the whole night and the day was not more than a watch and a half. He counted his wakefulness at night as so much added to his life. His courage and boldness were such that he could mount raging, rutting elephants and subdue to obedience murderous elephants which would not allow their own females near them." (Jahangir's *Memoirs,* tr. by Rogers and Beveridge, London, 1914, pp. 33–34).

Although Jahangir's recollections are of Akbar in full maturity, Akbar the boy must have been similarly magnetic, powerful, and effective. In 1556, at Panipat, his army defeated Hemu, the Hindu general of the Surs, who was dragged before him with an arrow skewered through an eye and out the back of his skull. The Mughals were never squeamish, but it must have been a terrible moment when Bairam Khan urged his young ruler to prove his valor by hacking off Hemu's head. Whether or not he did so, Akbar's view of Bairam Khan was changing from boyish hero worship to the discontent of a young man eager to be his own master. In 1560, Akbar broke his shackles by sending the general on a pilgrimage to Mecca. En route, Bairam Khan was killed by revengeful Afghans.

But this death did not fully free the young king. In Bairam Khan's place, a many-headed dragon of harem ladies became powers behind the throne for four more years. Coping with them, in addition to leading armies, organizing a state, and supervising the multifarious activities of a burgeoning culture, must have been frustrating indeed. It is no wonder that the young Akbar often tempted fate by subjecting himself to outrageous dangers, such as the one depicted in Plates 12 and 13, where he is shown riding an enraged elephant across a bridge of boats. In later years, he explained such madcap deeds to his friend and biographer Abu'l Fazl by saying that he deliberately risked death so that if God disapproved of his acts He could take his life.

A practical visionary, Akbar was amplified by at least two mystical experiences. The first took place when he was twenty, in 1562. Like Saint Paul, he was riding a horse that stumbled; although no engulfing flash of light was reported in Abu'l Fazl's account of the incident, "He, the wise and foreseeing one, regarded this as a message from God, and prostrated himself in devotion. A new foundation was laid for Divine worship." (*A'in-i-Akbari,* "Mode of Governing," vol. III, p. 338.)

At this time, Akbar took several steps crucial to the success of his empire. He overcame the clique of harem ladies, prohibited the enslavement of Hindu prisoners of war, allowed Hindus to occupy important governmental

posts, abolished a tax on pilgrims in 1563, and a year later did away with the *jizya,* a poll tax on non-Muslims. In 1562, he also married a Hindu princess, the daughter of Raja Bihar Mal of Amber.

All of these steps were radically at odds with Orthodox Muslim opinion. That he took them proves that he was ruling with full confidence and realized that the rift between Muslims and Hindus was the empire's greatest cause of disunity. Rajputs (Hindus of the warrior caste) were now more willing to serve the imperial cause, and further marital alliances with them brought Akbar powerful Rajput brothers-in-law, along with their armies. His military successes read like a grand tour: 1558, Gwaliar; 1560–62, Malwa; 1561, Jaunpur; 1568, Chitor; 1573, Gujarat; 1585, Kabul; 1586, Kashmir; 1592, Orissa; 1594, Baluchistan and Maran; 1595, Sind; 1596, Berar; and in 1600, several parts of Ahmadnagar in the Deccan.

With devious practicality, Akbar appointed Rajputs to high positions; and once they had tasted Mughal power, he controlled them by the carrot and stick policy. Loyal service earned promotions and enjoyable perquisites, such as the right to sound kettledrums or to wear prestigious ornaments; uncooperativeness courted disaster. Akbar realized the danger of united Rajput opposition, which could have driven the Mughals from Hindustan, and played upon the traditional rivalries among the Rajput clans, such as the Haras and Rathors. Moreover, he made it impossible for Mughal noblemen, whether Hindu or Muslim, to pass on power and wealth. At death, all lands, gold, elephants, horses, jewels, etc. reverted to the crown; and only if the emperor approved were the heirs permitted to inherit any part of their estates.

Rajputs and Muslims, however, were not the only members of Akbar's circle, nor were all his close associates Indian born. Word spread throughout the Muslim world that Akbar welcomed men of ability to his court. Poets, musicians, soldiers, theologians, painters, merchants, and others seeking fortunes were drawn from Turkey, Iran, and Arabia. Adventurers came from as far afield as Europe and Africa to add their talents to Akbar's cosmopolitan and glittering court.

The emperor also sought talent at home from all religious groups and ranks of society. He chose Raja Todar Mal, a Hindu of the business caste, as his revenue officer. Raja Birbal, a Brahmin, became one of Akbar's favorite companions, the so-called *nauratna* or Nine Jewels. Known for his wit and poetry, this man of religious background was one of the first to join Akbar's new sect, the *Din-i-Ilahi* or Divine Faith, another part of the imperial plan for the unification of India's disparate religious groups.

The Divine Faith probably grew from theological discussions held in a special hall at Fatehpur Sikri, the "City of Victory" founded by Akbar in 1563. Zoroastrians, Jains, Hindus and Muslims of all sects, and Christians joined in these serious all-night conversations, during which the emperor's questions often must have been as upsetting as they were penetrating.

Although his close associates joined, the Divine Faith was never a popular success and perhaps was not intended to be.

Akbar's projects were always purposeful; however diverse, all contributed to his grand imperial scheme. The translation into Persian of such Hindu religious works as the *Mahabharatta, Ramayana,* and *Harivamsa* (Plate 10) was intended to enlighten the Muslims of the empire and to further bridge the gap between them and the Hindus.

Although illiterate, Akbar loved books, particularly illustrated ones. His vast library included volumes that would now be catalogued as history, with particular emphasis on his own dynasty: natural history; medicine, including veterinary; anthropology; comparative religions; mathematics; engineering; military strategy; government; astrology; astronomy; and literature. The final volume of the *A'in* contains sections on the arts of writing and painting, sandwiched between discussions of shawls and stuffs and the royal arsenal.

Abu'l Fazl quotes the emperor's opinion of painting: "There are many that hate painting; but such men I dislike. It appears to me as if a painter had quite peculiar means of recognizing God; for a painter in sketching everything that has life, and in devising its limbs, one after the other, must come to feel that he cannot bestow individuality upon his work, and is thus forced to think of God, the giver of life, and will thus increase his knowledge." (*A'in*, p. 115). In his discussions of Akbar's thoughts on literature, Abu'l Fazl offers an apt description that can be equally applied to his taste in painting: "Most old authors who string out their words . . . and display a worn-out embroidery, give all their attention to the ornamentation of words, and regard matter as subservient to them, and so exert themselves in a reverse direction. They consider cadence and decorative style as the constituents of eloquence and think that prose should be tricked out like the works of poets."

A small percentage of Akbar's artists was inherited, including the Tabriz masters Mir Sayyid 'Ali and Abd us-Samad, who were put in charge of training many new ones. Akbar especially admired Hindu painters "whose pictures surpass our conception of things." (*A'in*, p. 114.) Although several distinguished artists came to the busy workshops from other Muslim centers, the majority of Akbar's over one hundred painters were probably recruited by military conquest, as part of the spoils of war. A fascinating manuscript of the *Tuti-nama* ("Tales of a Parrot"), most of whose miniatures are in the Cleveland Museum of Art, documents the formative period of Akbar's studios in about 1560, when the newly hired apprentices were being trained under the Tabriz masters. Among its two hundred and fifteen miniatures, many can be linked on stylistic grounds to earlier Rajput and Muslim styles, from Rajasthan, the Deccan, Central India, and elsewhere. (For a comprehensive study of the manuscript see Pramod Chandra, *The Tuti-nama of the Cleveland Museum of Art,* Graz, 1976.)

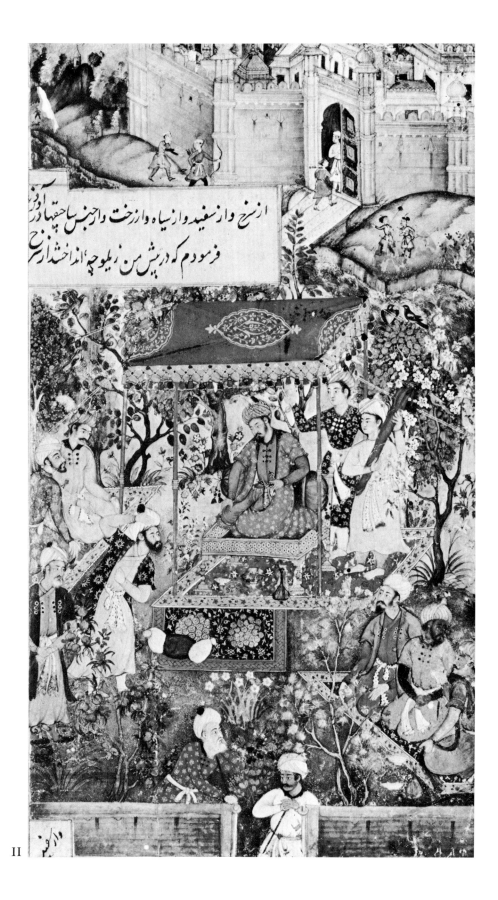

The most remarkable artistic project from Akbar's reign is the *Hamza-nama* ("Tales of Hamza"), a series of giant pictures on cotton describing the fabulous adventures of Amir Hamza, an uncle of the Prophet. The paintings are perfect visual equivalents of Akbar's surging spirit during the years when he had taken full control of the government and was advancing his schemes with godlike energy and intelligence. A picture such as *Mirdukht's Escape* (Plate 2) fairly bursts from the page. Water seethes and pounds, men dash, and the heroine gestures with theatrical bravado. Even the rocks are dynamic, recalling Abu'l Fazl's claim that "even inanimate objects look as if they had life." (*A'in*, pp. 113–114.)

An important category of Akbar's paintings are illustrations to *de luxe* volumes of the literary classics, of which an early example is *The Ape Outsmarts Thieves* (Plate 4) of 1570. Later examples are Plates 8, 9, and 11. Such pictures were invariably assigned to the most admired artists, working unassisted. But while these miniatures can be ranked as the atelier's "masterpieces," they are not necessarily the most exciting. Outstanding artists also worked on less refined projects, such as the copiously illustrated historical manuscripts that described not only Mughal history but also its precursors in the Islamic world. Perhaps the earliest surviving manuscript of this sort is a dispersed *Baburnama* (the Persian translation of Babur's autobiography) of about 1589, the year when the Khan Khanan, one of Akbar's most literary nobles, completed the translation. *Babur Receiving Uzbek and Rajput Envoys in a Garden at Agra* (Figure II) contains one of the most believable portraits of the founding emperor in his favorite garden surroundings, receiving envoys at Agra in 1528 from the Safavis, Uzbeks, and Rajputs. As usual under such circumstances at the Mughal court, robes of honor, gold and silver, and richly worked swords and daggers were presented to the guests.

More dramatic and immediate is *Akbar Restrains Hawa'i* (Plates 12–13), from another dispersed manuscript, the emperor's own copy of Abu'l Fazl's *Akbarnama*. As usual in Akbar's historical subjects, this magnificant composition was designed by a major artist, in this case Basawan, assisted by a lesser hand, here Chitra. The division of labor, however, was not tightly prescribed; and it is evident that even minor passages of this miniature were fully painted as well as designed by Basawan himself.

Not all of Akbar's pictures illustrated manuscripts. Many were made as independent compositions to be kept in albums. Some were animal studies. One such, among the earliest Mughal animal studies, is *Cow and Calf*, ascribable on stylistic grounds to Basawan (Figure III). More common at this time, however, were portraits of courtiers and others who interested the emperor. According to Abu'l Fazl, "His majesty himself sat for his likeness, and also ordered to have the likenesses taken of all the grandees of the realm. An immense album was thus formed: those that have passed away have received a new life, and those who are still alive have immortality promised

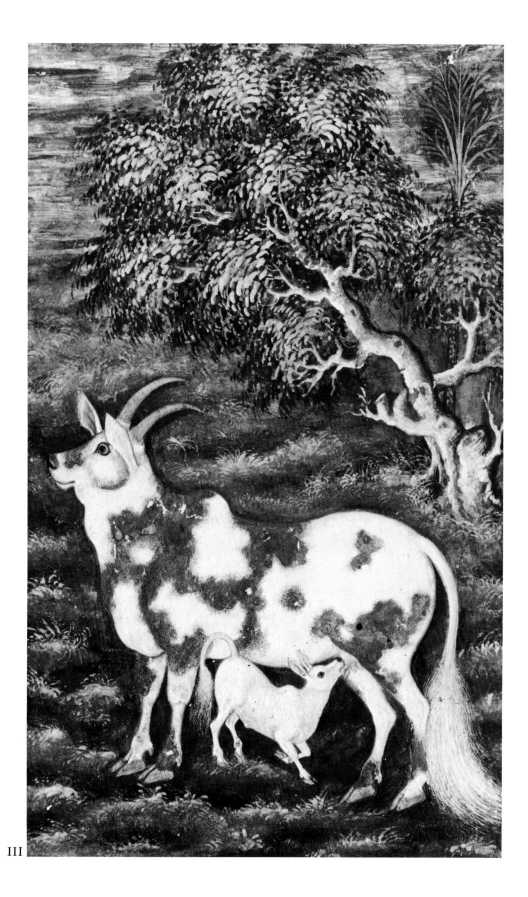

III

them." A portrait of a stout Muslim nobleman with bristling mustachios, craggy profile, and a wrestler's proportions probably belonged to this album (Figure IV).

Akbar's last years were soured by the rebelliousness of his son, Prince Salim (later Jahangir) who was impatient to rule. After 1600, he assumed royal prerogatives, and he once marched with a threatening army from Allahabad, where he was governor, towards the capital. Akbar was so alarmed that he ordered Abu'l Fazl to come from the Deccan to his aid. No confrontation took place; but after Abu'l Fazl threatened him, Salim promised favors to Bir Singh Deo, the Raja of Orcha, if he would assassinate his father's biographer and closest friend. A deadly ambush took place in August of 1602. Abu'l Fazl's severed head was sent to Salim, who tossed it into a privy.

It says much for Akbar that he spared Salim after such cruel behavior. For a time, he considered bypassing Salim in favor of his other surviving son, Danyal, in spite of the latter's serious addiction to alcohol, the family vice. Fortunately for Salim, Danyal died in 1604, after taking a final quaff smuggled to him in a rusty gun barrel. Salim's path to the throne was now clear.

Akbar's final illness began in September 1605, not long after his portrait was painted by Manohar (Plate 15). A month later, Salim ventured to his father's deathbed. Akbar "opened his eyes and signed (to his attendants) that they invest Salim with the turban and robes which had been prepared for him, and to gird him with his own dagger. The attendants prostrated themselves and did honor; at the same moment that sovereign, whose sins are forgiven, bowed himself also and closed his life." (Asad Beg, quoted by Elliot and Dowson, vol. VI, pp. 169–172.)

Nur-ud-din Muhammad Jahangir (1605–27)

On his accession, Prince Salim took the name Jahangir (the "World-Seizer"). He was the first Mughal ruler to inherit an empire worthy of the name. His *Memoirs* (the *Tuzuk-i-Jahangiri*) reveal him as a very human autocrat capable of touching kindness, occasional fickleness, outstanding aesthetic judgment, and endless curiosity. When he saw the imperial elephants shivering at their winter baths, he ordered that their water be warmed. One of his most charming buildings was a memorial to a pet antelope. But he was not a sentimentalist, and his hard-headed curiosity probed everywhere: when the milk of a particular camel pleased him, he investigated its diet and had the same mixture of cows' milk, fodder, and herbs given an entire herd. And when a huntsman cut open the stomach of a game-bird he had shot and showed him its repellent contents, he resolved never to eat another. Courtiers eager to please brought him strange news or unusual presents, such as exotic animals (Plate 27), European jewels or art, and oddments of nature. One of his daggers had a hilt of meteor.

In the *Memoirs,* he describes a hermaphroditic cat capable of both siring and bearing kittens. Less fruitful was the mating of a yogi with a tiger.

Another holy man, however, was taken far more seriously. Jahangir visited Jadrup, a breach-clouted hermit who lived in a tiny mud hut, and talked with him intimately and at length. On taking leave, Jahangir embraced him, much to the distress of his more orthodox courtiers.

Too often dismissed as a pleasure-loving dilettante of the arts, Jahangir in fact served his nation well. It prospered and was largely at peace during his reign; most of Jahangir's days were spent receiving visitors, administering justice, and attending to sundry imperial chores. To make himself available, he ordered that a rope attached to a bell be put within reach of those in need.

Although he dallied with a full harem of concubines and dancing girls, Jahangir was particularly devoted to one wife, Nur Jahan. She was born as Mehrunissa, the daughter of a Persian courtier who had risen in Akbar's service. Mehrunissa was first married to Sher Afkun, a soldier of fortune who was killed in Bengal. After his death, she returned to the imperial court as lady-in-waiting to one of Akbar's widows. At a bazaar held by the court ladies in 1611, she was sighted by Jahangir, who married her two months later. The titles he gave her, first Nur Mahal ("Light of the Palace") and later Nur Jahan ("Light of the World") are perhaps some indication of her ambition. With her she brought both her father, who had been honored with the title Itimad-ud-Daulah ("Pillar of Government") and Asaf Khan, her brother. The trio soon became the most powerful faction in the empire. Moreover, their influence lingered. For Prince Khurram, Jahangir's eldest son, who was to rule as Shah Jahan, married Nur Jahan's niece, the daughter of Asaf Khan. He was later rewarded with the position of chief minister after maneuvering Shah Jahan's succession. Still later his son, Shaisteh Khan, held high posts under Aurangzeb, Shah Jahan's son and successor.

Greatly interested in the arts, Nur Jahan commissioned one of the most elegant of all Mughal buildings as her father's tomb. She was also a taste-setter in costume and perfumery, a benevolent empress admired for providing dowries to needy girls, and a crack shot. Intrigue, however, was probably her greatest interest, and to follow her plots and sub-plots for and against potential inheritors of Jahangir's throne would require more words than we have. Notwithstanding her deviousness, she seems to have been truly devoted to Jahangir, whom she kept happy by every means she could, down to screening his dancing girls to make sure that they were sufficiently charming to please but not so charming as to endanger her own position. Although she earned the enmity of many rivals, and in the end she was outsmarted by her own brother in behalf of Shah Jahan, she remained a loyal wife, and her widowhood, spent in the shadow of Jahangir's tomb built by her near Lahore, was impeccable.

Jahangir died at fifty-eight, while encamped between Kashmir and Lahore. He had been failing for several years, apparently from a weak heart worsened by too much wine and opium, too much love-making, and the constant

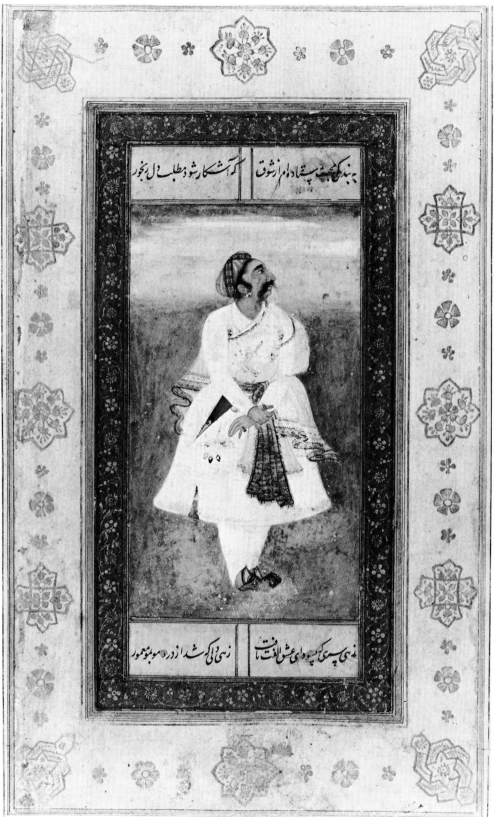

بہ بند کشف ستادہ ام از شوق کہ آشکار شود طلب دل بخور

زمی پسری کہ سودای عشق الفت نا زمی ژالی کہ رشہ ازدہ موبۂ معمور

strain of family intrigues. Not long before he died, he was kidnapped while leaving his bathroom. The villain was Mahabat Khan, a former friend and general who could no longer stomach Nur Jahan's slights. Although the affair fizzled out and no one was impaled or even hurt, it must have been exhausting. More deeply disturbing was the continuing rebelliousness of Shah Jahan, the crown prince and one-time favorite, who had also been alienated by Nur Jahan's schemes. In Jahangir's *Memoirs*, his rise and fall can be traced by changes of name: at birth he became Khurram ("Joyous"); in 1616, after he had subdued Mewar, the most reluctant of the Rajput principalities, he rose to Shah Khurram; a year later, following a diplomatic triumph in the Deccan, he was further elevated to Shah Jahan ("King of the World"); but from the time of his revolt in 1622, he was referred to as Bi-daulat ("Wretch"). Sadly, father and son never reconciled their differences and never again met.

Except possibly through his *Memoirs*, Jahangir is most accessibly and appealingly known through his paintings. If Jahangir's life at times reads like the plot of a romantic melodrama, his paintings reveal him as dead-earnest. They often give the impression of having been coaxed from the artists stroke by stroke, with each painted smile or scowl master-minded by the art-loving ruler. Preferring quality to quantity, and lacking his father's protean penchant for grandiose imperial projects, Jahangir greatly reduced the staff of the royal studios soon after his accession. This spread the Mughal style far and wide and enabled Jahangir to concentrate his attention on a small number of favored masters. As governor of Allahabad, he had maintained busy studios which included several of the artists who now blossomed under his imperial patronage. Prior to 1605, Jahangir's artists had already diverged from the more vigorous but less refined path of Akbar. They had been encouraged to paint with increased verisimilitude and subtlety, with softer colors, less turbulent rhythms, and more harmonious designs. Characterizations of both people and animals were gaining in depth and complexity.

As in Akbar's time, artists illustrated literary classics and histories of the reign (Plates 16–18); they painted animal studies (Plates 25–27), and portraits (Plates 19–24, 28, 29). But under Jahangir, the mood changed. Akbar's outgoing, objective, purposeful encouragement of painting was replaced by a more private vision. The subjects of Jahangir's pictures are often as quirky as his *Memoirs*. We can no more imagine Akbar asking his artists to record the last moments of a dying man (Figure V, Plate 23) than we can envision Jahangir commissioning a picture of a Hindu god in order to encourage religious toleration among his Muslim courtiers (Plate 10). Nor would Akbar have directed his painters to illustrate wish-fulfilling allegorical pictures based upon his own dreams (Plate 21). It would also have been unlike him to set such consciously art-historical tasks as adding a self-portrait of an artist painting a scribe at work to the colophon page of a favorite manuscript (Plate 19); or the "translation" of less viable figures in Persian miniatures

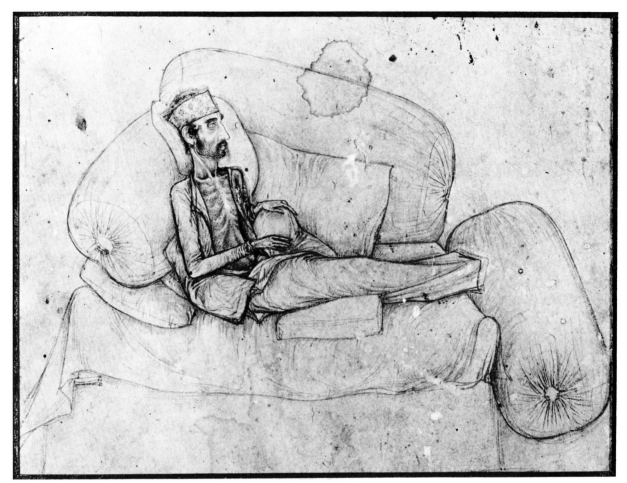

by totally repainting them as realistic Mughal ones.

Jahangir's interest in painting was passionate and connoisseurly. "As regards myself," he wrote, "my liking for painting and my practice in judging it have arrived at such a point that when any work is brought before me, either of deceased artists or of those of the present day, without the names being told me I say on the spur of the moment that it is the work of such and such a man. And if there be a picture containing many portraits, and each face be the work of a different master, I can discover which face is the work of each of them. If any other person has put in the eye and eyebrow of a face, I can perceive whose work the original face is, and who has painted the eye and eyebrow." (Memoirs, II, pp. 20, 21.) On the sixth of August in 1616, when Sir Thomas Roe, the English ambassador, had given Jahangir a painting that he "was confident that noe man in India could equall," the emperor boasted that one of his artists could make a "Coppy soe like it that I should not knowe myne owne." That night, "hee sent for mee, being hastie to triumph in his workmen, and shewed me 6 Pictures, 5 made by his man, all pasted on one table (cardboard), so like that I was by candle-light troubled to discerne which was which . . . " Pleased with his artist's success, Jahangir "was very

merry and joyful and craked like a Northern man." (*The Embassy of Sir Thomas Roe*, William Foster, ed., London 1899, vol. I, pp. 224, 225.)

Shahab-ud-din Muhammad Sahib Qiran Sani Shah Jahan (1628–1658)
Like his father, Prince Khurram was born of a Rajput mother. His early years were spent at the court of Akbar, who admired him above all his other grandchildren and at whose deathbed Khurram remained to the end. Intelligent and effective, he was responsible as a young prince for most of the military successes during his father's reign. Although he was first betrothed at fourteen, when he also received his first military rank and the right as eldest son to pitch a red tent, he did not marry Mihrun-Nisa (Nur Mahal, "Light of the Palace"), daughter of Asaf Khan and niece of Nur Jahan, until 1612. Best known as Mumtaz Mahal, she was as devoted to Khurram as her aunt, Nur Jahan, was to Jahangir. But unlike her aunt, she avoided intrigue. She bore fourteen children, among whom were: 1614, Jahanara; 1615, Dara Shikoh; 1616, Shah Shuja; 1617, Roshanara Begum; 1618, Aurangzeb; 1624, Murad Bakhsh; and 1631, Gauhar Ara Begum, at whose birth she died. The Taj Mahal (1632–48) was built as her tomb.

Although the tranquility of Shah Jahan's reign was marred by occasional rebellions and wars with the Safavis over Qandahar (Plate 33), it was notably peaceful and prosperous until his serious illness in 1657.

In that year, the fear that he might die sparked the wars of succession, one of the most tragic and destructive phases of Mughal history, in which brother was pitted against brother in a contest of military strength, intrigue, and duplicity. Shah Jahan's favorite son, Dara Shikoh, whose religious tolerance was unattuned to the spirit of the time, lost to the orthodox and militarily effective Aurangzeb. In 1658, after imprisoning Shah Jahan in the fort at Arga (where he died at seventy-six in 1666), Aurangzeb assumed the throne as 'Alamgir I.

Since the beginning of Akbar's region, the Mughal ethos had gradually become more rigid. In religion, Akbar's inspired toleration of non-Muslims and encouragement of heterodoxy was lessening towards the end of his reign, and this trend gained momentum during the seventeenth century. Symptoms of this tightening can be found in all aspects of Mughal life and thought. They are clearly visible in paintings, as can be seen by comparing the sweeping dynamism of pages from the *Hamza-nama* (Plates 1–3) with the tranquil harmonies of *The Birth of a Prince* (Plate 16). A further step towards crystalline coldness is apparent in a double-page miniature from the Shah Jahan-nama, the last great Mughal historical manuscript. Appropriately, this tautly disciplined composition shows a gathering of the religious orthodoxy prior to the marriage of Prince Dara Shikoh (Plates 31–32). Had one of Akbar's courtiers wandered into such a scene, he would have found the atmosphere stifling.

Human beings, and particularly artists, however, continued to find ways to

express their inner freedom. While Prince Dara Shikoh's recklessly unortho-
dox views cost him his life (he was executed as a heretic after a formal trial
by the judges of the realm), Payag the painter was able to vent his wilder
moods in a battle scene notable for *sturm und drang* (Plate 33). Moreover,
the deep romantic love of Shah Jahan and Mumtaz Mahal is paralleled in a
painting by Bal Chand of Shah Shuja gazing into the eyes of his wife (Plate
35).

'Alamgir I and the Later Emperors

Abu'l Zafar Muhi-ud-din Muhammad Aurangzeb 'Alamgir (1658–1707)

'Azam Shah (1707)

Kam Bakhsh (1707)

Mu'azzam Shah 'Alam I, Bahadur Shah (1707–1712)

'Azim-ush Shah (1712)

Mu'izz-ud-din Jahandar Shah (1712–1713)

Muhammad Farrukhsiyar (1713–1719)

Rafi-ud-darajat (1719)

Rafi-ud-daulah, Shah Jahan II (1719)

Muhammad Shah (1719–1748)

Ahmad Shah (1748–1754)

'Azziz-ud-din 'Alamgir II (1754–1759)

Shah Jahan III (1759)

Mirza 'Abdullah 'Ali Gohar, Shah 'Alam II (1759–1788)

Bidar Bakht (1788–1806)

Akbar Shah II (1806-1837)

Bahadur Shah II (1837–1858)

Shah Jahan's third and hardiest son, 'Alamgir I, brought the Mughal em-
pire to its peak of power and wealth after conquering the Sultanates of the
Deccan in the late seventeenth century. In so doing, however, he over-
extended its boundaries, and his reversal of Akbar's religious policies so
offended the Rajputs and other Hindus that many turned from friends into
foes. He was brilliantly unwise and often ruthless, but he was also known for
his gentleness of manner, thoughtfulness, and piety. A zealously orthodox
Sunni, he copied out Qu'rans, tore down Hindu temples, and built mosques.
He was the busiest of all Mughal emperors. Before he died at ninety, he
realized that his policies had in fact weakened rather than strengthened the
empire.

At once the upholder and victim of orthodoxy, his legalistic position
forced him to turn against such arts as dance, music, and painting. Although
his portrait with a son and Shaisteh Khan (Plate 37) and a hunting scene
(Plate 38) are among the finest Mughal pictures of their genres and suggest
that he had a true feeling for the art, by 1668, when he promulgated restric-
tive religious ordinances, he virtually closed the royal ateliers. As at the
beginning of Jahangir's reign—although for quite different reasons—impe-

rial Mughal artists spread to other courts.

Further wars of succession followed the death of Aurangzeb in 1707. And while Bahadur Shah I won and survived a short reign, most later Mughal history can be seen as a peculiar nightmare, unwinding like a crazed film with a cast of thousands. Ambitious, greedy courtiers became king-makers; dancing girls played tinsel Nur Jahans; wrestlers and buffoons assumed noble titles; pimply adolescents occupied thrones—until they were strangled, to be replaced by senile puppets.

As in the past, weakness attracted predators. But the pace quickened, and most of the personalities in this grand tragicomedy lacked dignity. Freebooters from the Deccan, Maharashtra, and England joined the chaotic struggle for power once restricted to Rajput princes and Muslim noblemen. Imperial eyes were gouged out with penknives; royal bodies were carted unceremoniously from the palace. Towards the end, princes fought over bits of *chapati* (flat bread).

Occasionally the empire fared better. Even when the government had collapsed, Mughal literature, art, and manners were respected and emulated. Muhammad Shah, whose reign was interrupted by Nadir Shah's invasion and looting, was a gifted musician with a keen eye for painting. An imperial artist painted his slightly bovine form being carried through a delightful garden (Plate 39); and while the silhouetted flowers and vivid rainclouds are more perceptively handled than the emperor's mask-like face, it was probably not a good time to scrutinize imperial countenances.

Mostly due to Akbar's extraordinary formula for government, the Mughal empire took a long time to die. The central power somehow withstood wave after wave of attacks. As the structure gave way, strong nobles created their own domains, in Bengal, Oudh, and Hyderabad, where new schools of painting, based on the imperial tradition, flourished. Even at the center, artists continued to paint up-to-date versions of the traditional hunts and court scenes, although such costly pigments as lapis lazuli were in ever shorter supply.

A final Mughal portrait shows the last emperor, Bahadur Shah II, accompanied by two of his sons, seated beneath Shah Jahan's marble scales of justice (Plate 40). The gilt lions of the throne now resemble poodles and the emperor himself has taken on a look of disembodied spirituality, with the deeply set eyes of some Byzantine saint. His dignity remains, however, and it is heartening to know that while more than a century has passed since he was exiled to Burma by the British, musicians still sing his verses in Delhi.

Selected Bibliography

Historical Works: Primary Sources

ABU'L FAZL ALLAMI. *A'in-i Akbari.* Translated by H. Blochmann and Col. H. Jarrett. Calcutta, 1875–1948.

————. *Akbarnama.* Translated by H. Blochmann. Calcutta, 1907.

BEVERIDGE, A. S., trans. *The Babur-nama in English.* London, 1969.

ELLIOT, SIR H. M. and DOWSON, J. (ed.) *The History of India as Told By Its Own Historians.* London, 1867–77.

FOSTER, W., ed. *The Embassy of Sir Thomas Roe to India 1615–1619.* London, 1926.

JAHANGIR. *Memoirs.* Translated by A. Rogers, edited by H. Beveridge. London, 1909.

SHAH NAWAZ KHAN. *Ma'asir-ul Umara.* Translated by H. Beveridge and Baini Prashad. Calcutta, 1911–1952.

Historical Works: Secondary Sources

GASCOIGNE, B. *The Great Moghuls.* London, 1971.

PRASAD, B. *History of Jahangir.* Allahabad, 1940.

PRASAD, I. *Life and Times of Humayun.* London, 1955.

SAKSENA, B. P. *Shah Jahan of Dilhi.* Allahabad, 1932.

SARKAR, SIR J. *The Fall of the Mughal Empire.* London and Calcutta, 1912–1930.

————. *History of Aurangzeb.* Calcutta, 1925.

SHARMA, S. R. *Mughal Empire in India.* Agra, 1971.

Painting

ARNOLD, SIR T. W. and WILKINSON, J. V. S. *The Library of A. Chester Beatty: A Catalogue of the Indian Miniatures.* London, 1936.

BROWN, P. *Indian Painting Under the Mughals.* Oxford, 1924.

CHANDRA, M. *The Technique of Mughal Painting.* Lucknow, 1946.

CHANDRA, P. *The Tuti-Nama of the Cleveland Museum of Art.* Graz, 1976.

COOMARASWAMY, A. K. *Catalogue of the Indian Collections in the Museum of Fine Arts, Boston, Part 6, Mughal Painting.* Cambridge, 1930.

DICKINSON, M. B. and WELCH, S. C. *The Houghton Shahnameh.* (forthcoming)

EGGER, G. *Hamza-Nama.* Graz, 1974.

32 ETTINGHAUSEN, R. *Paintings of the Sultans and Emperors of India*. Delhi, 1961.

GLUCK, H. *Die Indischen Miniaturen des Hamsae-Romanes*. Vienna, 1925.

GODARD, Y. "Les Marges du murakka Gulshan," *Athar-e Iran 1*. Haarlem, 1936.

GRAY, B. "Painting," *The Art of India and Pakistan*. ed. Sir Leigh Ashton. London, 1950.

KUHNEL, E. and GOETZ, H. *Indian Book Painting*. London, 1926.

SKELTON, R. "The Mughal Artist Farrokh Beg." *Ars Orientalis 2*. Ann Arbor, 1957.

————. "Mughal Paintings from Harivamsa Manuscript," *Victoria and Albert Museum Yearbook 2*, pp. 41–54. London, 1969.

STCHOUKINE, I. *La Peinture Indienne*. Paris, 1929.

WELCH, S. C. "The Paintings of Basawan," *Lalit Kala 10*. Delhi, 1961.

————. *The Art of Mughal India*. New York, 1963.

————. *A Flower from Every Meadow*. New York, 1973.

————. *Indian Drawings and Painted Sketches*. New York, 1976.

————. *A King's Book of Kings*. New York, 1972.

————. *Persian Painting*. New York, 1976.

List of Color Plates & Black-and-White Figures

I.

Three illustrations to the *Hamza-nama* ("Tales of Hamza"), ca. 1567–82
Museum of Applied Arts, Vienna
ca. 70 x 52 cm.
Plate 1. *Hamza's Spies Attack the City of Kaymar* (52/1 8770/25)
Plate 2. *Mirdukht's Escape from Dangerous Men* (52/1 8770/32)
Plate 3. *A Banquet for Two Spies at Akiknigar* (52/1 8770/59)

II.

Miniature from the *Anwar-i-Suhaili* (The Lights of Canopus"), 1570
The School of Oriental and African Studies, London
folio 33.3 x 22.2 cm.
Plate 4. *The Ape Outsmarts Thieves*

III.

Two miniatures from the *Darabnama* ("The Tales of Darab") of Abu
 Tahir ibn Hasan Musa al-Tarasusi, ca. 1585
The British Library, London
folios 35 x 22.5 cm.
Plate 5. *Shah Ardashir's Fate,* Or. 4615, f. 3v (34 x 20 cm.)
Plate 6. *Tamarusa and Shapur at the Island of Nigar,* Or. 4615, f. 34r
 (25 x 19 cm.)

IV.

Album Painting *A European* ca. 1590
The Victoria and Albert Museum, London, I.M. 386–1914
30.0 x 18.3 cm.
Plate 7. *A European*

V.

Miniature from the *Baharistan* ("The Spring Garden") of Jami (A copy
 made at Lahore by Muhammad Husayn Zarin Qalam in 1595)
The Bodleian Library, Oxford
21.5 x 14.6 cm.
Plate 8. *The Foppish Dervish Rebuked,* by Basawan, Elliot 254, f. 9r

VI.

Miniature from a dispersed *Divan* of Hafiz (?), ca. 1590
Freer Gallery of Art, Smithsonian Institution, Washington
28.1 x 15.6 cm.
Plate 9. *Noah's Ark* (attributable to Miskin), 48.8

VII.

Miniature from a dispersed *Harivamsa* ("Geneology of Hari"), ca. 1585–90

The Metropolitan Museum of Art, New York

29.0 x 20.0 cm.

Plate 10. *Lord Krishna Lifts Mount Govardhan* (by Miskin?) 28.63.1

VIII.

Miniature from a dispersed *Anwar-i-Suhaili* ("The Lights of Canopus") (?) ca. 1590

The British Museum, London

27 x 19.4 cm.

Plate 11. *The Raven Addressing the Assembled Animals* (by Miskin?) 1920 9–17–05

IX.

Double-page miniature from an incomplete copy of the *Akbarnama* ("The History of Akbar") by Abu'l Fazl, ca. 1590

The Victoria and Albert Museum, London

Plate 12. *Akbar Restrains Hawa'i* I.S. 2-1896 22/117, 34.5 x 21.7 cm.

Plate 13. *Spectators* I.S. 2-1896 21/117 34.5 x 21.6 cm. (Both designed by Basawan and painted with Chitra's assistance)

X.

Miniature from an incomplete copy of the *Akbarnama* ("The History of Akbar") by Abu'l Fazl, ca. 1590

The Victoria and Albert Museum, London

Plate 14. *Akbar Hunting in an Enclosure* (Designed by Miskin, painted with Sarwan's assistance), ca. 35 x 22 cm. I.S. 2-1896 56/117

XI.

Album painting, *Akbar in Old Age* (inscribed "the work of Manohar Das"), ca. 1604

Cincinnati Art Museum

24.4 x 14.7 cm. with border/18.4 x 12.1 cm. miniature only

Plate 15. *Akbar in Old Age* (Listening to a Courtier), 1950–289

XII.

Miniature from a dispersed copy of the *Jahangir-nama* ("The History of Jahangir"), ca. 1605–10

Museum of Fine Arts, Boston

26.4 x 16.4 cm.

Plate 16. *The Birth of a Prince* (attributable to Bishndas), 17.3112

XIII.

Miniature from a dispersed copy of the *Jahangir-nama* ("The History of Jahangir"), ca. 1620.

Museum of Fine Arts, Boston

34.5 x 19.5 cm.

Plate 17. *Jahangir in Darbar* (probably by Abu'l Hasan and Manohar), 14.654

XIV.

Miniature from a dispersed copy of the *Tuzuk-i-Jahangiri* ("The Memoirs of Jahangir"), ca. 1615

The British Museum, London

26.6 x 20.5 cm.

Plate 18. *Prince Khurram (later Shah Jahan) Weighed Against Metals* 1948 10–9 069

XV.

Miniature added to a *Khamsa* ("Quintet") of Nizami dated 1597–98, ca. 1610

The British Library, London

22.5 x 14 cm. text area

Plate 19. *Self-Portrait with a Scribe* (inscribed "Daulat the Painter and 'Abd al-Rahim the Scribe"), Or. 12208, f. 325v.

XVI.

Album Painting *A Thoughtful Man*, ca. 1610–15

Museum of Fine Arts, Boston

10.3 x 12.2 cm.

Plate 20. *A Thoughtful Man* (inscribed on border "the work of Muhammad 'Ali"), 14.633

XVII.

Album Painting *Jahangir's Dream*, ca. 1618–22

Freer Gallery of Art, Smithsonian Institution, Washington

24 x 15 cm.

Plate 21. *Jahangir's Dream* (Signed Abu'l Hasan, Nadir al-Zaman "The Wonder of the Age"), 45.9

XVIII.

Album Painting *Jahangir Enthroned on an Hourglass*, ca. 1625

Freer Gallery of Art, Smithsonian Institution, Washington

25.4 x 18.2 cm. without border

Plate 22. *Jahangir Enthroned on an Hourglass* (by Bichitr), 45.15a

XIX.

Album Painting *'Inayat Khan Dying*, ca. 1618

The Bodleian Library, Oxford

12.5 x 15.3 cm.

Plate 23. *'Inayat Khan Dying*, Ouseley add. 171 b 4 r

XX.

Album Painting *Hindu Holy Men*, ca. 1625

Private Collection, courtesy of the Fogg Art Museum

23.8 x 15.2 cm.

Plate 24. *Hindu Holy Men* (attributable to Govardhan)

XXI.

Album Painting *Squirrels in a Plane Tree*, ca. 1610

India Office Library, London

36.5 x 22.5 cm.

Plate 25. *Squirrels in a Plane Tree* (probably by Abu'l Hasan, Nadir al-Zaman "The Wonder of the Age" perhaps with the help of Ustad Mansur, Nadir al-Asr, "The Miracle of the Age"), Johnson album 1, no. 15

XXII.

Album Painting *Peafowl,* ca. 1610
Private Collection, courtesy of the Fogg Art Museum
19 x 10.9 cm.
Plate 26. *Peafowl* (Attributable to Ustad Mansur, Nadir al-Asr, "The Miracle of the Age")

XXIII.

Album Painting *A Zebra,* dated 1621
The Victoria and Albert Museum, London
18.3 x 24.1 cm. miniature/26.8 x 38.7 cm. folio
Plate 27. *A Zebra* (Inscribed by Jahangir, "A Zebra which the Rumis (Turks) brought from Abyssinia with Mir Jaffar painted by Nadir al-'Asr, the Miracle of the Age, Ustad Mansur, in 1621, the sixteenth year of the reign"), I.M. 23-1925

XXIV.

Album Painting *A Rustic Concert,* ca. 1625
The Chester Beatty Library, Dublin
23 x 16.5 cm.
Plate 28. *A Rustic Concert* (by Govardhan), Royal Album 7, 11

XXV.

Album Painting *A Scribe,* ca. 1625
Private Collection, courtesy of the Fogg Art Museum
10.5 x 7.1 cm.
Plate 29. *A Scribe*

XXVI.

Opening folio from an album *Shamsa* ("Sunburst," inscribed with the titles of Shah Jahan (1627–58) "May God Make His Kingdom Last Forever!"), ca. 1640.
The Metropolitan Museum of Art, New York
91.5 x 63 cm.
Plate 30. *Shamsa,* 55.121.10.39

XXVII.

Double page miniature painted for the *Shah Jahan-nama* ("The History of Shah Jahan") in the Windsor Castle Library, completed in 1656–57 by the scribe Muhammad Amin of Mashhad, ca. 1650
Freer Gallery of Art, Smithsonian Institution, Washington
35.1 x 24.2 cm. inside borders
Plates 31 and 32. *Shah Jahan Honors the Religious Orthodoxy* (attributable to Murad), 42.17A and 18A

XXVIII.

Miniature painted for the *Shah Jahan-nama* ("The History of Shah

Jahan") in the Windsor Castle Library, completed in 1656–57 by the scribe Muhammad Amin of Mashhad, ca. 1653
Private Collection, courtesy of The Fogg Art Museum
34.3 x 23.9 cm.
Plate 33. *An Incident at the Siege of Qandahar,* (attributable to Payag)

XXIX
Album Painting *An Abyssinian from Ahmadnagar,* ca. 1633
Private Collection
15 x 8.1 cm.
Plate 34. *An Abyssinian from Ahmadnagar* (inscribed "the work of Hashim")

XXX.
Album Painting *Royal Lovers on a Terrace,* ca. 1633
Private Collection
22.5 x 13.1 cm.
Plate 35. *Royal Lovers on a Terrace* (signed "the work of Bal Chand")

XXXI.
Album Painting *Dara Shikoh with Sages in a Garden,* ca. 1640–50
The Chester Beatty Library, Dublin
27.7 x 19.8 cm.
Plate 36. *Dara Shikoh with Sages in a Garden* (signed "the work of Bichitr"), Royal Albums, 7, 7

XXXII.
Album Painting *Darbar of 'Alamgir,* ca. 1658
Private Collection
19.1 x 21.4 cm.
Plate 37. *Darbar of 'Alamgir*

XXXIII.
Album Painting *'Alamgir Hunting Nilgai,* ca. 1660
The Chester Beatty Library, Dublin
23.7 x 39.4 cm.
Plate 38. *'Alamgir Hunting Nilgai* (attributable to Bichitr), Separate Miniature no. 27.

XXXIV.
Album Painting *Muhammad Shah Viewing a Garden,* ca. 1730–40
Museum of Fine Arts, Boston
38.3 x 42.5 cm.
Plate 39. *Muhammad Shah Viewing a Garden*

XXXV.
Album Painting *Bahadur Shah II,* dated 1838
Private Collection
32 x 38 cm.
Plate 40. *Bahadur Shah II*

I.

Painting on cloth *The House of Timur*, ca. 1550–60
The British Museum, London
108.5 x 108 cm.
Figure 1. *The House of Timur*, 1913 2–8 1

II.

Miniature from a dispersed copy of the *Baburnama* ("The History of Babur"), a Persian translation of Babur's *Memoirs* prepared for Akbar in 1589, ca. 1589
The Victoria and Albert Museum, London
24.2 x 13.7 cm.
Figure II. *Babur Receiving Uzbek and Rajput Envoys in a Garden at Agra* (painted by Ram Das), I.M. 275–1913

III.

Album Painting *Cow and Calf,* ca. 1570
Private Collection
28.3 x 18.3 cm.
Figure III. *Cow and Calf* (attributable to Basawan)

IV.

Album Painting *A Muslim Nobleman,* ca. 1585, border ca. 1610.
Private Collection
20 x 11.8 cm. folio/10.1 x 6 cm. miniature only
Figure IV. *A Muslim Nobleman*

V.

Preparatory Drawing *The Death of 'Inayat Khan,* ca. 1618
Museum of Fine Arts, Boston
9.5 x 13.3 cm.
Figure V. *The Death of 'Inayat Khan,* 14.679

Plates and
Commentaries

40

PLATE 1

Hamza's Spies Attack the City of Kaymar

The most powerful of all Mughal pictures are doubtless the large illustrations to the tale of Hamza, an uncle of the Prophet, whose deeds became confused with those of a namesake from Sistan during the reign of Harun al-Rashid. His picaresque exploits in China, Central Asia, Rum (Turkey), and Ceylon were grist for the storyteller's mill, whose embroideries upon them were interpreted with imaginative flair by Akbar's artists. According to Abu'l Fazl, in the *Akbarnama,* in 1564 the emperor relaxed after an elephant hunt at Narwar by listening to these stories. No doubt, they were read with dramatic flourishes to him and his companions by a professional reciter whose descendants still delight Indian audiences. Conveniently, the text was written on paper stuck to the backs of the large cotton cloth pictures which he held up to the listeners.

Although fewer than one hundred and fifty pages have survived, this vast project, according to Abu'l Fazl, once consisted of twelve volumes, with 1400 illustrations. Bada'oni, another contemporary chronicler, tells us that the project took fifteen years to complete. A reliable eighteenth-century source, the *Ma'asir ul Umara* ("The Feats of the Mughal Commanders") adds that fifty painters of the calibre of Bihzad, generally considered the greatest Persian artist, worked on the project, which was begun with Mir Sayyid 'Ali in charge and was later directed by Abd us-Samad. On the basis of a close reading of relevant sources, Pramod Chandra has proposed convincingly that the project dates from 1567 to 1582 *(op. cit., Tuti-nama).*

Hamza's Spies, with its magnificent trees, charming monkeys, and blood-and-guts action, combines eye-boggling power and beguiling subtleties, and typifies this project at its best.

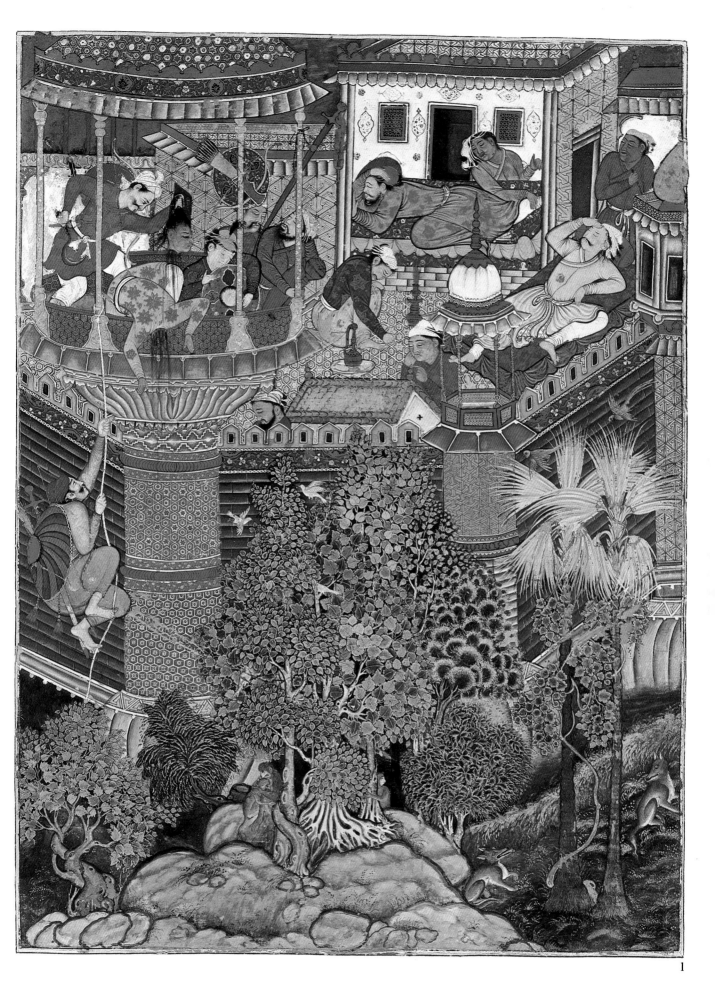

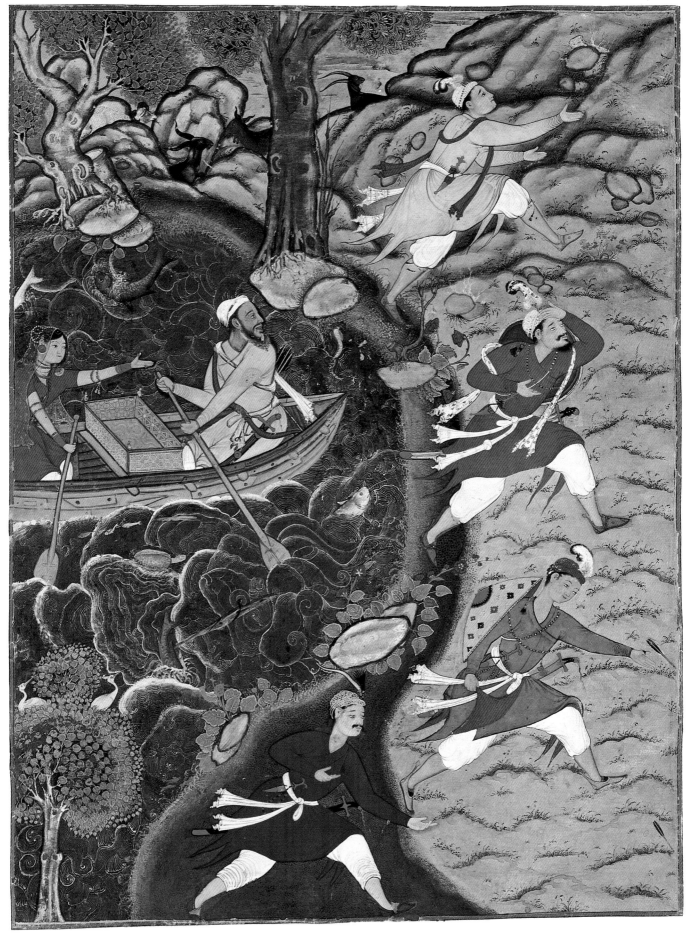

2

PLATE 2

Mirdukht's Escape from Dangerous Men

Akbar's vital power, harmoniously attuned to nature's force, was never better expressed than in the illustrations to his *Hamza-nama*. According to Abu'l Fazl, he met with his artists once each week. If this is accurate, and we suspect that it refers to his later, less intense years rather than to the period of the *Hamza*, enough time was provided for him to so inspire his painters that he virtually painted through them, in much the same way that Abu'l Fazl was his literary amanuensis. Abd us-Samad, the second director of the project, had been a somewhat conventional artist prior to the time when, according to Abu'l Fazl, "he was stirred to new heights by the alchemy of Akbar's vision, and he turned from outer form to inner meaning " (see Dickson and Welch, *The Houghton Shahnameh*, forthcoming).

Few pictures are more spirited than *Mirdukht's Escape*, with its whiplash division of land and water, dashing figures, and dramatic gesticulations, worthy of the grandest opera. The water is a sinuous maelstrom of leaping fish and other aquatic life. Pondering it imaginatively releases yet other, wilder forms, cavorting in its turbulence: ape-like faces, the profile heads of a ram and an ibex, a lion bellowing at a fish, and numerous other grotesqueries. Such hidden images abound in the rocks, water, and tree stumps of early Akbari painting, but become scarcer towards the end of the sixteenth century, when increasing orthodoxy discouraged all that was so earthy, intuitive, and "superstitious." (Enjoy, however, the horse's head poking from a stump in Plate 8.)

PLATE 3

A Banquet for Two Spies at Akiknigar

Akbar's pictures reflect his achievements as well as moods and interests. Here, the spies and their party are entertained by strange men probably based upon people Akbar encountered on some expedition. They resemble exponents of tantric religion, perhaps from Nepal or Tibet. One, sporting a white plume, has slanted eyes and a flattened Mongol nose. A Tibetan horn is among the weapons and musical instruments strung in an arcade behind the figures. In the background, at the right, other extremists strain *bhang,* a concoction of marijuana often used by holy men. Surrounded by their mysterious bowls, the busy pair sits beneath a writhing tree, with branches and bark suggestive of hallucinations to come.

Like the other paintings of the *Hamza* series, this one was designed to be effective across a room or courtyard. The colors are high in saturation and contrast: whites are dead-white; oranges and yellows leap at us. Similarly, the patterns of tiles, stonework, and ornamentally disposed foliage are daringly bold. Nonetheless, close inspection is rewarding. The characterizations were painted for a man who could size up his fellows at a glance, and wherever we look, whether at the host's coral and turquoise belt, also typical of Nepal and Tibet, or at the outlandish gilt-bronze incense burner in the foreground, there is something to surprise and delight. It is no wonder that of all the loot carried off from Delhi by Nadir Shah in 1739 (including the Peacock Throne), it was only the *Hamza-nama,* "painted with images that defy the imagination," that Emperor Muhammad Shah pleaded to have returned.

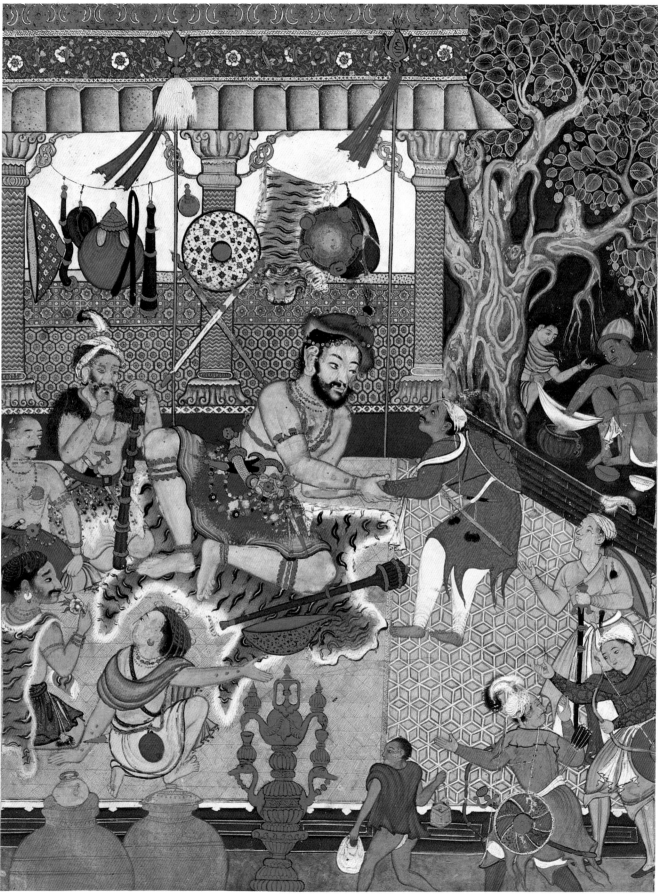

3

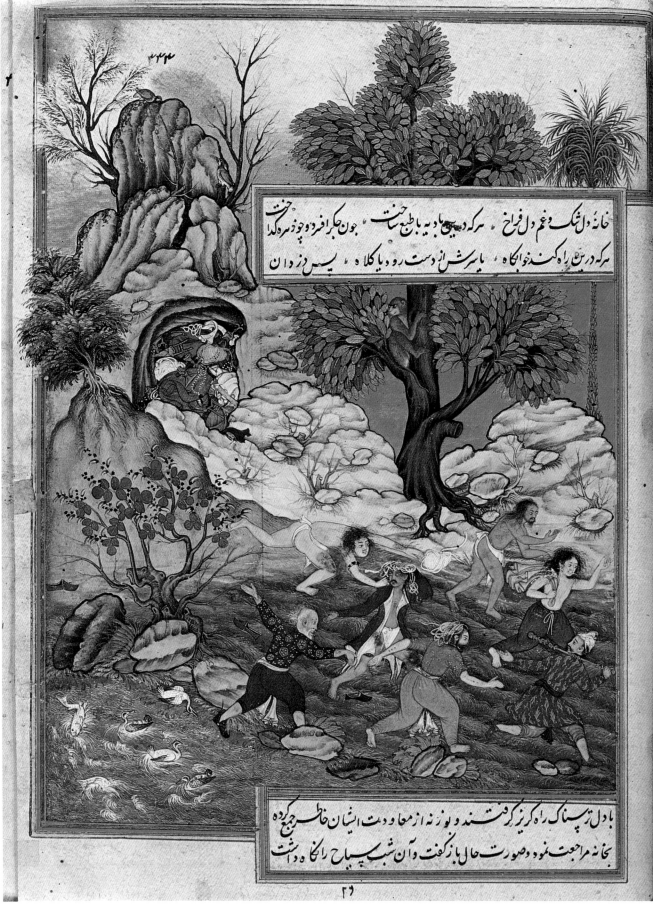

خانهٔ دلتنگ و غم دل فراخ • هر که دبیر بادیه با طبع خفت • جون جگر افسرده و چوپان مرده گدا
هر که در بیع راه کمند خوابگاه • یا بسر شل از دست رو یا کلاه • پس دزدان

با دل ترسناک راه کریز گرفتند و یوزنه از معاد و دست ایشان خاطر جمع کرده
بخانه مراجعت نمود و صورت حال باز گفت و آن شبش سیاح راکاه دوشت

PLATE 4

The Ape Outsmarts Thieves

Fable books were popular at Akbar's court, particularly when he was young. The Brahmin Bidpai's ancient stories, amusing yet moralistic and didactic, were retold by royal command, like glittering beads refaceted and restrung.

This painting illustrates the story of a clever and honorable ape who befriends a traveller who had been robbed. Noting that the robbers had fallen asleep after hiding their loot, he removed many of the valuables and secreted them elsewhere, after which he climbed a tree and had the satisfaction of seeing the thieves awaken, discover their loss, and, in the belief that their hiding place was haunted, rush off in terror. Later, the ape led the traveller to his stolen goods.

This painting is from one of the earliest dated Mughal manuscripts, and proves that by 1570 Akbar's artists worked in a thoroughly synthesized style drawn mostly from Safavi and indigenous elements. Although no artists' names are inscribed, the miniatures all seem to be by the most admired masters, presumably working under the strict control of Abd us-Samad, Mir Sayyid 'Ali, and the emperor himself. Paper, calligraphy, illumination, and paintings in this volume are all of the highest quality. It is probably the earliest surviving specimen of Akbar's *de luxe* series of illustrated classics.

PLATE 5

Shah Ardashir's Fate

Although undated and bearing neither the name of the scribe nor the place of origin, the *Darab-nama* with its 155 miniatures can be assigned to Lahore, shortly after Akbar moved there in 1585. Many of the miniatures are inscribed by the clerk in charge of the project with the names of notable court artists, including Miskin, Basawan, Farrukh Chela, and Abd us-Samad. Several pictures in an old-fashioned Persianate style almost uninfluenced by the court idiom bear such names as Ibrahim of Lahore, leading one to further conclude that their style lingered from the days of Lahore's pre-Mughal rulers.

The paper for this volume is relatively coarse, and its calligraphy is inelegant, perhaps because it was created before the imperial workshops were fully settled in the new capital. Nevertheless, it contains many exciting pictures, painted somewhat thinly but with enlivening inventiveness.

This painting shows Shah Ardashir, who, while riding in the mountains, was surprised from behind by a dragon and devoured in a gulp. When the news of his terrible fate spread, all the princes of the world went into deep mourning for three months. His son went off to Hindustan and never returned.

Although the artist's name is illegible, he rivalled Basawan for originality and power of design. With its all-encompassing landscape, the painting seizes the two blocks of text like a dragon, as fiercely as the monster gobbled up Shah Ardashir. Through his total conviction and such subtleties as Ardashir's almost blank expression, a response slowed by the utter horror of circumstance, the artist makes us believe a fantastic tale.

که ولایت را انگنند و شیر گفت من پر دم و شیر غرو را کفایت کنم در خود معنی آورد و شها بر نشستند و فتند

تا بدان کوه که پرسید پیچی بر از دراز ان کوه به پروان آمد و دمن باز کرده و آتشی در دمید در ان صحرا جنان که

بهمن دریت و بهای فرو مرد و خواست که بهر میت به میان رود که از آن در هشته آمد و پیچید ه او در کشیده و او دران

از دهانا پدید کشت خبر در جهان افتاد که اردشیر را از در غرو در جمله امر اجمع شدند و سه ماه تعزیت داشتا

وزاری بسیار کردند و امرایی که در مظالم نشستند و تخت بی نشاه ماند و اردشیر راپسری

باسام به هند و سیستان رفت و پیش نها مدا اینان گفتند با نشامی باشتی که قابل

و اری و تخت بودی با رشنوا و پهلوان باج کشاد و کفت هما را بر تخت بنشانیم که شایسته تر ت و فرزند لهراسپ

و پیره اسفندیار ست و انخه به کلوکیت به دین پنج جله رضا داد و نه و تخت رایاری ستند و و جاج اردشیر در هما

بو شاندند و رشنوا که لنامک او لبو تاج اسفند یار بر سرو نهاد ند و کم کتاب بر میان او لبت و لختین شته

رالخت او کردند و هما را بتخت بنشاند ند و جمله امیران و بزرگان بپیش او پیش بو میدن و زمین بوس کردند و سر بر او رد

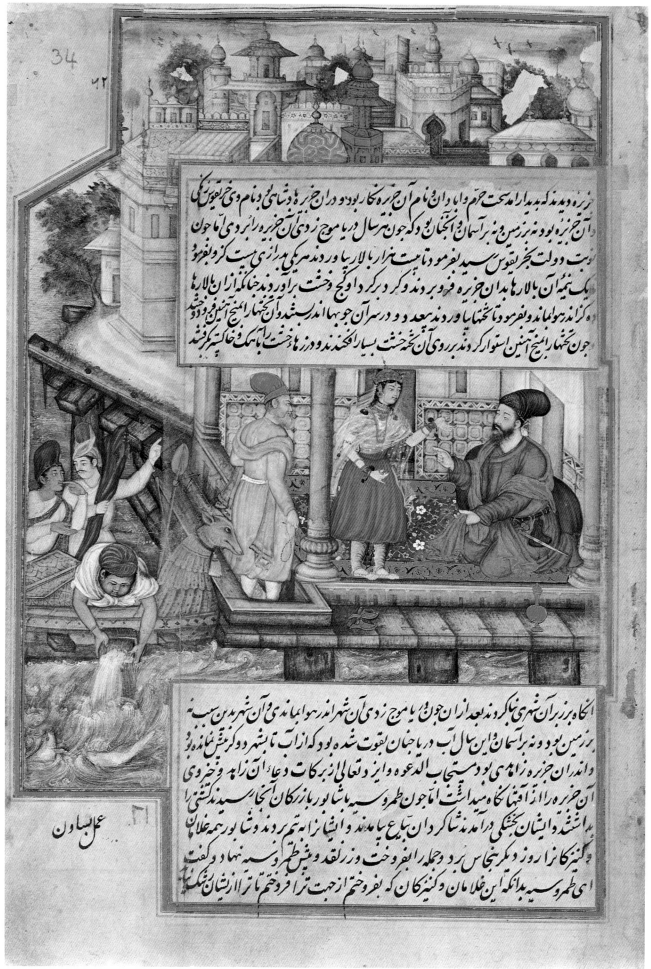

جزیره دیدند که بدید دار امد سحت جرم و ایا بدان نام آن جزیره نکار بود و در ان جزیره بادشاهی بنام وخی یقوس بک ی
ان آن جزیره بود و نه بر زمین و نه بر آسمان وی انچنان بود که جون بر سال سال موج دریا زدی بدان جزیره را برد ی ما جون
سبب دولت بخر یقوس سید بفرمود تا بست هزار بالارها آورد ندبه هر یکی مهرازی بست کرد و بفرمود و
یک نیمه آن بالارها بدان جزیره فرود برد ند و کرد یک دایوج بخت و آن یک بخت و آورد بخان که از ان بالارها
داکر دند به و لمانده بفرمود تا تخشنا بارا آورد ند و بعد ا و در سران جو بها اندر بسند و آن تخشنا را مس آهنی و و خشید
جون تخشنا را مس آهنی استوار کردند بر بر روی آن تخشه خشت بسیار افکند و در زبان خشت با سمک و خاکسر کرفند

انکاه بر بز بر ان سهری نگا کرد و از ان جون بای موج زدی ان سهر اندر هوا بماند ی وی آن شهر بد ن سبب نه
بر زمین بود و نه بر آسمان وی ای ن سال سال آب دریا جهان بقوت شده بود که از اب نا سهر دو کر نی نمانده بو
و اندر ان جزیره زاهدی بود دستجاب الدعوه و ایز دتعالی از برکات دعای آن زاهد زاده و خر و ی
آن جزیره را از آفتاب نگاه میداشت امنا جون طمو سیه باشا بود بازرگان انجا سید که کشتی را
بدانشید و ایشان بخشکی درآمد ند شاکر د ان تبایع بار مدند و ایشان زا بهم برد ند و بشا بور ترجمه غلام
کنیز کا را روز دیکر بنجاس برد و جمله را بفرخت و زر نقد و بخش طمو سیه نهاد و سیه و کفت
ای طمو سیه بدانکه این غلام ان و کنیز کان که بفرختم ترا فروختم از جهت زحمت تا از ایشان رنگ شک

PLATE 6

Tamarusa and Shapur at the Island of Nigar

Abu'l Fazl tells us that "the works of all painters are weekly laid before His Majesty by the Daroghas and the clerks." (A'in, p. 113) At such meetings, Akbar and his artists must have exchanged views and decided what subjects to depict. Here we find the work of one of Akbar's recruited Hindu artists, Basawan, one of the four artists singled out by Abu'l Fazl as "among the fore-runners of the high road of art." Of Basawan he wrote, "In designing, paint-ing faces, coloring, portrait painting, and other aspects of this art, he has come to be uniquely excellent. Many perspicacious connoisseurs give him preference over Daswanth," the other Hindu master discussed by Abu'l Fazl (translation after P. Chandra, op. cit.).

This painting, one of the best from the Darab-nama, shows Tamarusa (or Tahrusiyyeh) and Shapur at the Island of Nigar, a remarkable place ruled by a king named Kharikus, prior to whose reign it was engulfed by the sea. Under his direction, a huge city was built on pilings, which are clearly visi-ble in the painting. Basawan is here represented at the height of his form, stimulated perhaps by the move from Fatehpur Sikri to Lahore, with its new sights and sounds. He approached the subject freshly, as though glad to go back to work. The geometric cityscape (an idealized view of Lahore?), the strongly shaded bulk of Kharikus, and the challengingly honest foreshorten-ing of the bailing sailor make this picture memorable.

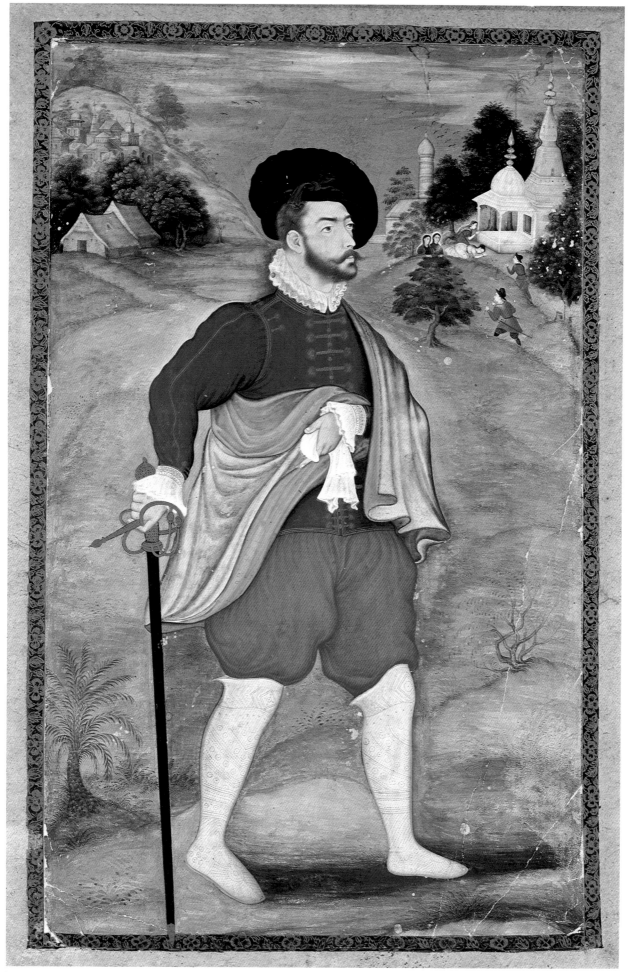

7

PLATE 7

A European

Akbar was intrigued by the exotic merchant-adventurers from the west. He first encountered them at Cambay in 1572. A year later, during the Siege of Surat, a large party of Christians came for an audience with him and was asked to guarantee the safety from pirates of Muslim pilgrims to Arabia. In 1576, Akbar met two Jesuit priests in Bengal with whom he discussed religion, one of his favorite topics. He tried unsuccessfully to learn more about Christianity a year later, from the commandant of the port at Hugli, a Portuguese trading center in Bengal. In the next year, another such encounter proved unrewarding, and in 1579, he requested that missionaries be sent to court from Goa, the Portuguese center on the West coast. In 1580, Fathers Aquaviva, Monserrate, and Henriques came to Fatehpur Sikri "to convert the inhabitants of Mogor." Abu'l Fazl, author of the *Akbarnama,* was asked by Akbar to translate the Gospels. No copy has survived, if indeed the project was completed. Although Akbar is said to have kissed the image of Christ, and Christian paintings were made by Mughal artists at this time, the Jesuits commented that "giving the pearl of the Gospels to the King was exposing them to be trampled and trodden underfoot." In 1590 and 1594, further missions were sent from Goa to the Mughal court. Brother Benedict de Goes remained in Lahore until 1615. Although the Jesuits never completely gave up hope of converting Akbar, and later Jahangir, Jesuits were not allowed to visit Akbar when he was on his deathbed.

This portrait of a European was probably based upon imported prints as well as direct observation. The Christian ladies at worship resemble Hindus bowing before a Sivaite image, and their shrine recalls contemporary Hindu architecture.

PLATE 8

The Foppish Dervish Rebuked

When the wise and holy sufi Abu'l 'Abbas Qacab came upon a foppish dervish, busily sewing his artfully ascetic robe, he spoke strongly: "That robe is your God!"

Basawan unfailingly strikes dramatic chords. Here, the lively wiggling of the dervish's patched coat captures our eyes immediately, and from it we are led to the two men: the glowering, hostile fop and the firmly persuasive sufi. After making his dramatic points, the artist lets us expore further. We enjoy Basawan's world of suckling animals and take in the baroque rhythms of entwining trees. Counterpointing the anecdote, one of nature's best attired creatures, a peacock, strides on the rooftop and huffily turns his back on his "holy" rival. But in Basawan's work there is always more to find, such as the chambers and passageways of a massive Mughal building, into which he lures us, and where imponderables await. This picture, from one of Akbar's most precious copies of a literary classic, represents Basawan's mature style.

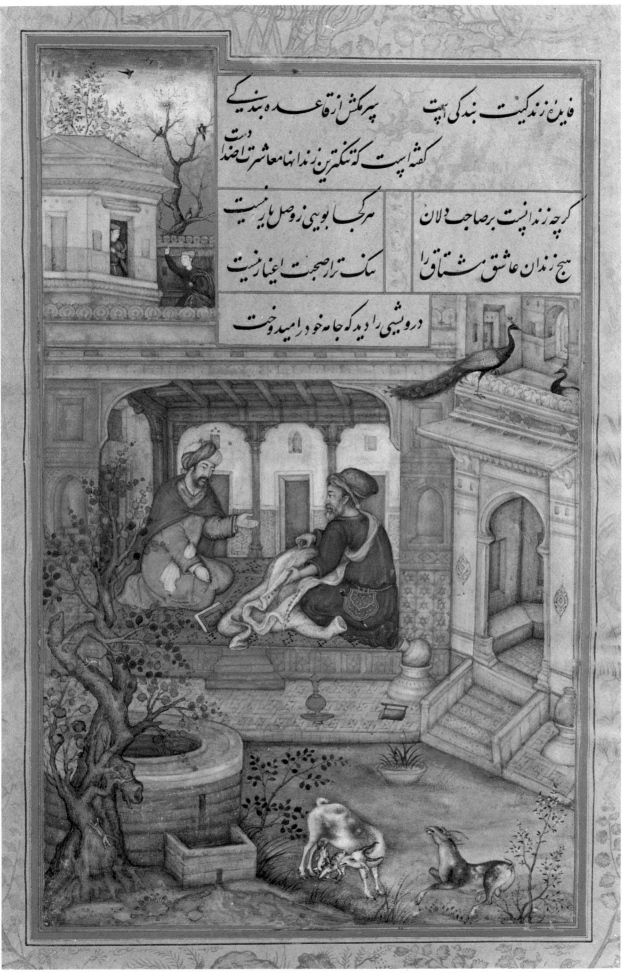

فایده زندگی بندکی ایست

پهرکش از قاعده بندکی

کسه ایست که تنگترین زندانها معاشرت اضداد

دست

گرچه زندانیست بر صاحب دلان

هرکجا بویی ز وصل یار نیست

هیچ زندان عاشق مشتاق را

کنگ تر از صحبت اغیار نیست

درویشی را دید که جامه خود را امید و خت

8

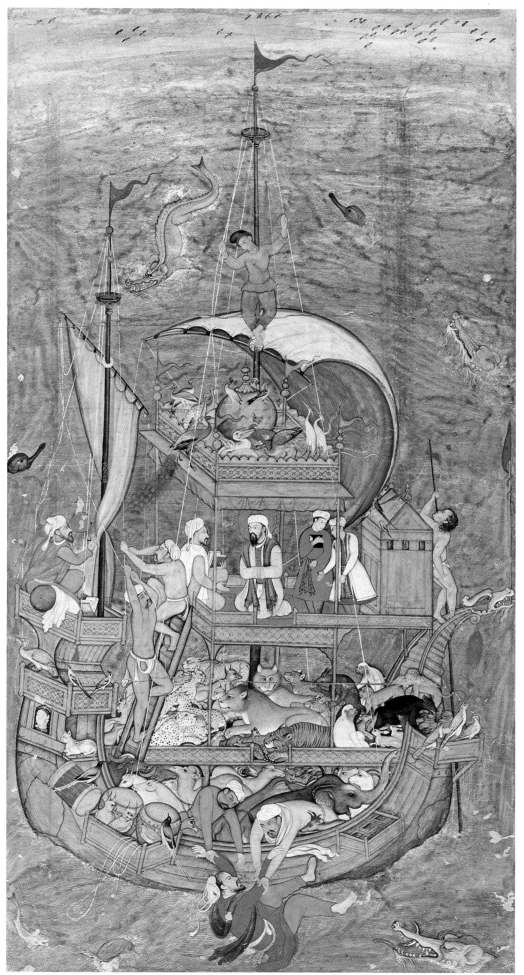

PLATE 9

Noah's Ark

According to Muslim tradition, Noah's ark was threatened by Iblis, the devil, who was thrown overboard, as here, by his sons. This delightful retelling of the story can be ascribed to Miskin, one of Akbar's greatest artists, whose sleek, often humorous animals are unmistakable. As usual in his work, some of the animals here were studied from life, while others—such as the dippy lioness staring at us from the crowded hold—emerged from Miskin's inner zoo.

Miskin was happiest with a subdued palette, as here, to which he added a few bright accents. His compositions are organic, bringing to mind such natural patterns as the roots of trees or veins of leaves.

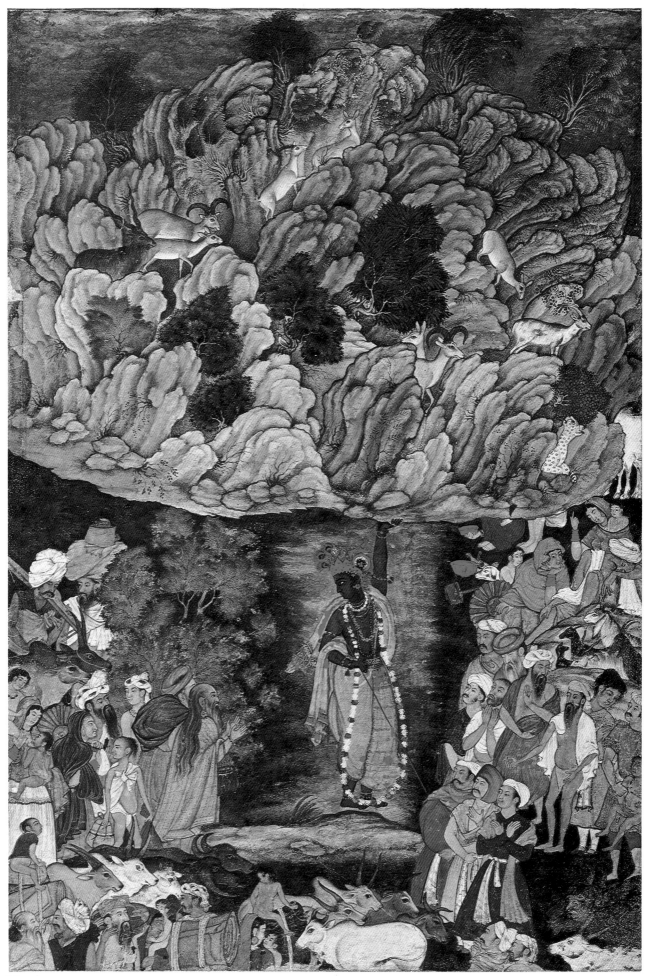

10

PLATE 10

Lord Krishna Lifts Mount Govardhan

To protect his followers from the wrath of the rival God Indra, who has conjured up a holocaust, Krishna lifts Mount Govardhan like some huge umbrella. The villagers and their herds evoke today's India and must have been even more familiar to sixteenth-century viewers. Such pictures were intended by Akbar to explain Hinduism to his Muslim courtiers, and thereby instill them with religious toleration. The artist, therefore, has made every effort to lend credibility to the God's miracle.

Amusingly, Akbar assigned one of his most orthodox Muslim men of letters to translate the *Harivamsa*—Badaoni, the author of the *Muntakhabu-t-Tawarikh* ("Selections from Histories"). Unlike Abu'l Fazl, whose *Akbarnama* he must have considered pure propaganda, Badaoni strongly disapproved of Akbar's religious policies, and it is remarkable that the emperor suffered him so leniently. Inasmuch as Badaoni's *Selections* is a rich source of personal anecdote ("gossip"), it seems likely that the emperor found him as amusingly informative as we do.

With slight reservations, we assign this delightful painting, with its humorously characterized people and animals, to Miskin.

PLATE 11

The Raven Addressing the Assembled Animals

This mountain of birds and beasts may come from the copy of the *Anwar-i Suhaili* prepared for Akbar by Abu'l Fazl himself. Its large scale and brilliantly imaginative conception link it to such manuscripts as the *Harivamsa* (Plate 10) and the *Akbarnama* (Plates 12–14).

Although natural history paintings were especially favored by Akbar's son, Jahangir (Plates 25–27), Akbar's paintings, while less sensitively naturalistic, are imbued with fuller animal vitality. Without sacrificing their endearing innocence, Miskin painted birds and animals with high spirits and wit verging on human personality. As late as 1590, the ambiance of Akbar's circle was still earthy and intuitive; Akbar and his artist could empathize with all creatures, a talent progressively inhibited by sophistication and self-consciousness. Here there is a perfect coordination of feeling, insight, and technical refinement.

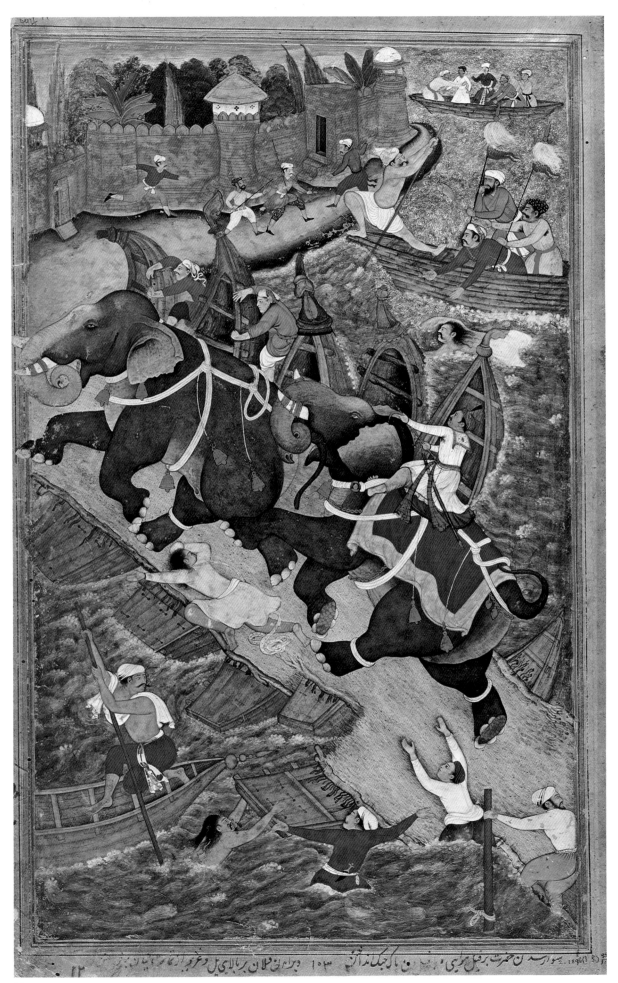

سوارسد ان حضرت بر فيل عربى و برين ن پاک جنگل نداند ۱۰۳ وهرانى سلطان بربالاى فيل قرغرجوارازنهرستان ینان رفت

12

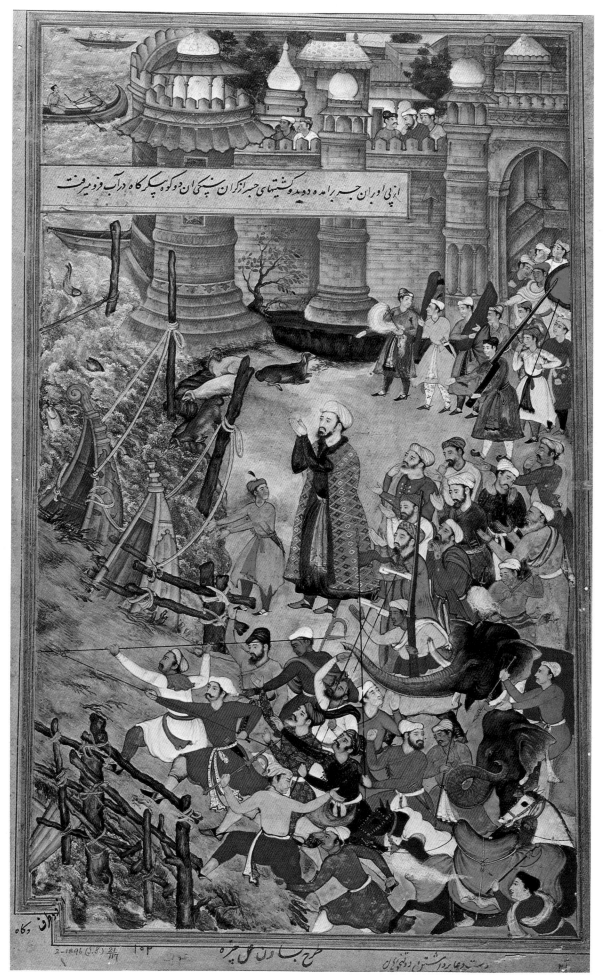

PLATES 12–13

Akbar Restrains Hawa'i, an Enraged Elephant and *Spectators*

This double-page composition is one of the most exciting miniatures from the copy of Akbar's biography by Abu'l Fazl owned by the emperor himself. The episode is best described in the author's words:

"Hawa'i ("Sky-Rocket") was a mighty animal . . . a match for the world in choler, passionateness, fierceness and wickedness." Elephant drivers mounted him with difficulty and scarcely dared make him fight. Akbar, then nineteen, however, mounted Hawa'i at the very height of his ferocity and pitted him against Ran Bagha, a beast of almost equal power. Such behavior "turned the gall-bladder of the lion-hearted to water." Atga Khan, Akbar's prime minister, was summoned to put a stop to this imperial folly. He came, bared his head, cried, and lamented. But Akbar persisted until Hawa'i had triumphed over his opponent. Ran Bagha turned to flee, pursued by Hawa'i. After a long chase, he came to the river Jamna and the great bridge of boats. Some of the pontoons were submerged, others lifted up under the weight of the animals. Akbar restrained Hawa'i's fiery temper; Ran Bagha escaped with his life. Later, the emperor told Abu'l Fazl that he knowingly and intentionally mounted on murderous elephants in heat ". . . thereby putting himself at God's mercy, for he could not "support the burden of life under God's displeasure."

(paraphrased and quoted from the *Akbarnama,* vol. II, pp. 234–235)

PLATES 12–13 Continued

Akbar's illustrated historical manuscripts are among the most vivid in Islamic art; and his *Akbarnama,* of which 117 folios are in the Victoria and Albert Museum, is certainly the most compelling among them, although it is uneven in quality. While some pages are comparatively monotonous, pictures such as this one crackle with energy, carrying the observer into the action. Very likely, artists were present at some of the events depicted. An artist such as Basawan, however, possessed such a creative imagination that he could envision episodes such as this, making every gesture and expression convincing. Here, he has painted elephants seldom equalled in Indian art—a great achievement considering that elephants were a specialty of Indian artists. But his involvement in this miniature did not stop at the main subject: he was equally interested in the gesture of the muscular boatman in the distance who poles his barge across the river with mighty thrusts. Even the wooden piles lashed with ropes at the lower left of Plate 13 attracted Basawan so much that he colored them himself, in a series of blazing flourishes.

Although this manuscript of the *Akbarnama* was probably completed in about 1590, it is likely that the project began at least five years earlier, probably as Abu'l Fazl completed writing his accounts of the episodes. Very likely, too, he and Akbar assigned the subjects to the artists best qualified to depict them. In this picture, Basawan's boatman, with his expressive distortions of canon, harks back stylistically to the *Hamza-nama* (Plates 1–3).

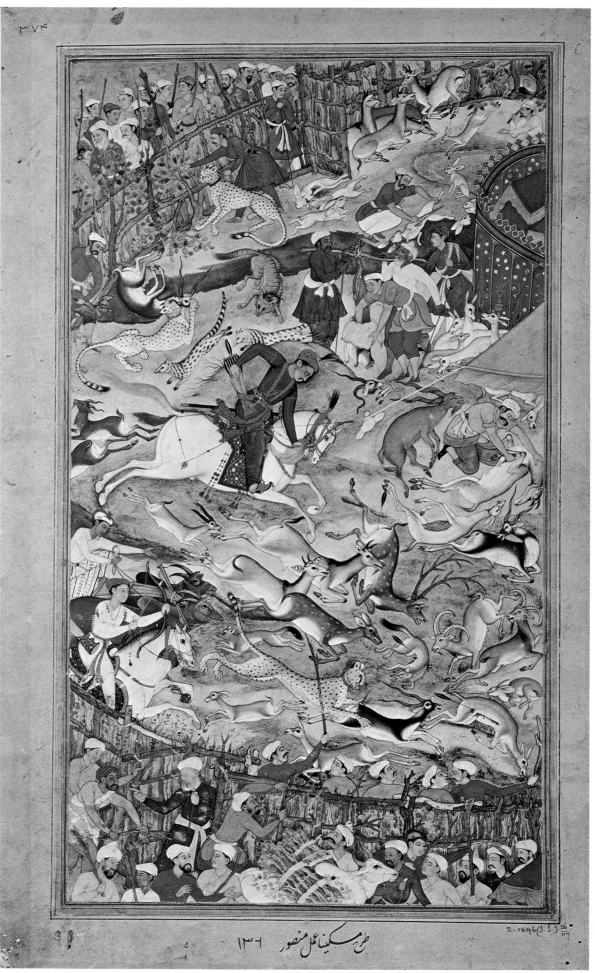

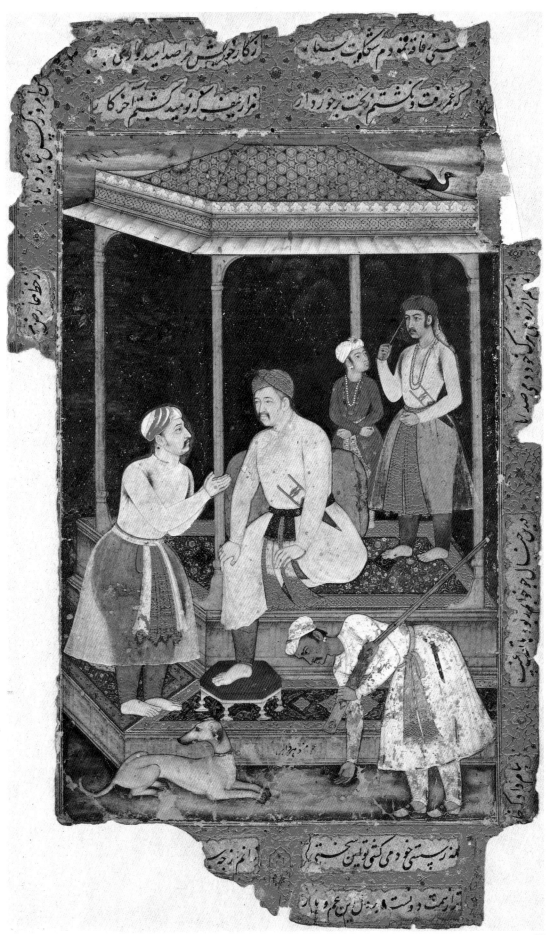

PLATE 14

Akbar Hunting in an Enclosure

Aided by cheetahs and huntsmen, Akbar gallops through an enclosure of animals, firing arrows at the trapped beasts, in a hunting technique known as *qamargah*. During such a hunt, near Bhera, when he was thirty-six in 1578, Akbar was disgusted by the slaughter and ordered his men to cease. The carnage had so disturbed him that it sparked a religious experience. In the words of Abu'l Fazl, "A sublime joy overtook his bodily frame. The attraction of cognition of God cast its ray." Afterwards, "active men made every endeavor that no one should touch the feather of a finch and that they should allow all the animals to depart according to their habits." Later, Akbar gave much gold to the holy men and poor of the region, and when he returned to Fatehpur Sikri, he filled a large tank in the palace with money for charity (*Akbarnama*, vol. II, pp. 245–254).

Hunting was an ancient royal activity, perhaps traceable to the need of villagers for protection against lions and tigers. In time, it became ritualized and took on symbolic meaning. In such combats, kings, representing goodness, slew evil beasts, as part of life's cosmic pattern.

Conceivably, Miskin was aware of both the symbolic and worldly significance of his miniature, which ranks artistically with *'Alamgir Hunting Nilgai* (Plate 38), to which it offers many comparisons. While the mood of the earlier hunt is informal, noisy, and wildly energetic, the later one is orderly, courtly, and hushed.

PLATE 15

Akbar in Old Age

Looking pallid and drained, Akbar is shown in old age, probably not long before his death at sixty-four in 1605. Behind him, seemingly worried, his grandson Prince Khurram (later Shah Jahan) turns to his bibulous older brother, Prince Khusrau. The courtier saluting the emperor appears to be Hakim 'Ali Gilani, the physician who attended Akbar in his last illness and who was also Prince Khurram's chief tutor. An unidentified huntsman tries unsuccessfully to attract the attention of a hound. He holds a superb green matchlock, symbolic perhaps of activities forsaken in old age.

Manohar's group portrait sensitively conveys a mood of sadness and tension, and as such it is a landmark in the development of its genre, which could be considered the outstanding expression of Mughal art. This sensitive, three-quarter view of Akbar may be the very picture that provided the model for countless posthumous likenesses, such as those made for Shah Jahan, who must have remembered his grandfather as we see him here, and who remained at his bedside until the end.

PLATE 16

The Birth of a Prince

Jahangir's historical pictures transport us into Mughal times. Bishndas's description of the birth of a prince, probably of Jahangir himself, is unusually rich in anecdote. Through his eyes, we peer into the harem, where the proud mother (a Rajputni entitled Mariam Zammam) is being shown her infant, surrounded by fellow wives, eunuch guards, servants, and musicians. A very senior wife (probably Akbar's mother, Mariam Makani), seated in an armchair, shares her pleasure, while others register moods varying from amusement to jealous rage. A sumptuously gilded and jewelled crib awaits the baby; distant nursemaids gossip and gather necessaries; and, below, royal attendants bring trays of presents, presumably from Akbar. Flowers are strung across the harem door, which is also protected by a curtain, around which a curious nursemaid steals a peep. In the foreground, seated against a red sandstone wall typical of Fatehpur Sikri, astrologers prepare the prince's horoscope.

Bishndas was one of Jahangir's ablest portrait painters. In his *Memoirs* in the fourteenth year of his reign, Jahangir wrote, "At the time when I sent Khan 'Alam (as ambassador) to Persia, I had sent with him a painter of the name of Bishan Das, who was unequalled in his age for taking likenesses, to take the portraits of the Shah and the chief men of his state, and bring them. He had drawn the likenesses of most of them, and especially had taken that of my brother the Shah exceedingly well, so that when I showed it to any of his servants, they said it was well drawn." Later, he added, "Bishan Das, the painter was honored with the gift of an elephant." (*Memoirs,* vol. II, pp. 116–117.)

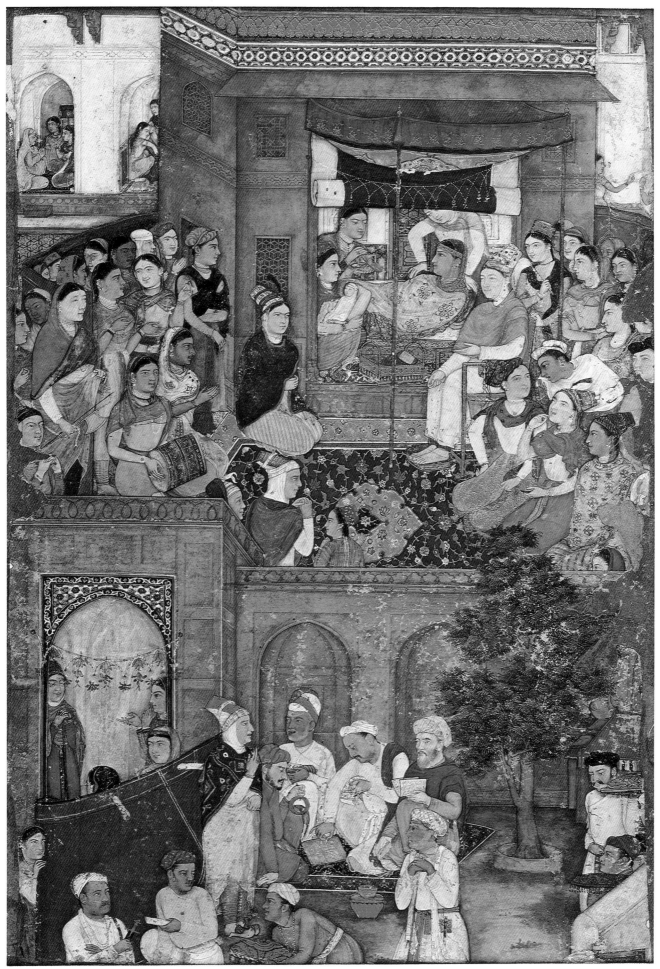

PLATE 17

Jahangir in Darbar

Jahangir is shown in the audience hall at Agra receiving a typical assembly. Nearest him stands his four-year-old grandson, Prince Shah Shuja (Plate 35), who was brought up at court by Jahangir and Nur Jahan. Next to him is his father, Prince Khurram (Shah Jahan) with his hands ceremoniously crossed. Among the many courtiers below the throne is a Jesuit priest, Father Corsi, whose name is inscribed.

Impressive with their wealth of textiles, jewels, animals, and reverential nobles, such scenes were almost daily events at the imperial court, where protocol became increasingly rigid and complex, determining where one stood, what one wore, and the precise positions of one's hands. Artists were in attendance to make sketches from which to paint illustrations, such as this one, for official histories.

Jahangir was realistic about his appearance and urged artists to paint him, as here, with every wrinkle and jowl. Many of the lesser figures were depicted with less attentiveness. They do not interact, and most of their heads are inconsistent in scale because they were pounced from the life-drawings that were part of every court portraitist's equipment. Although each nobleman was rendered accurately, gatherings of them were symbols of the emperor's total domination, human bouquets for an autocrat. Occasionally noblemen were painted in *darbar* scenes who are known not to have been there, or even to have died prior to the event.

This picture, which must have been painted for the largest and finest history of Jahangir's reign, is inscribed "Work of the humble house-born (artists)." Although the names are not given, they were probably Abu'l Hasan and Manohar.

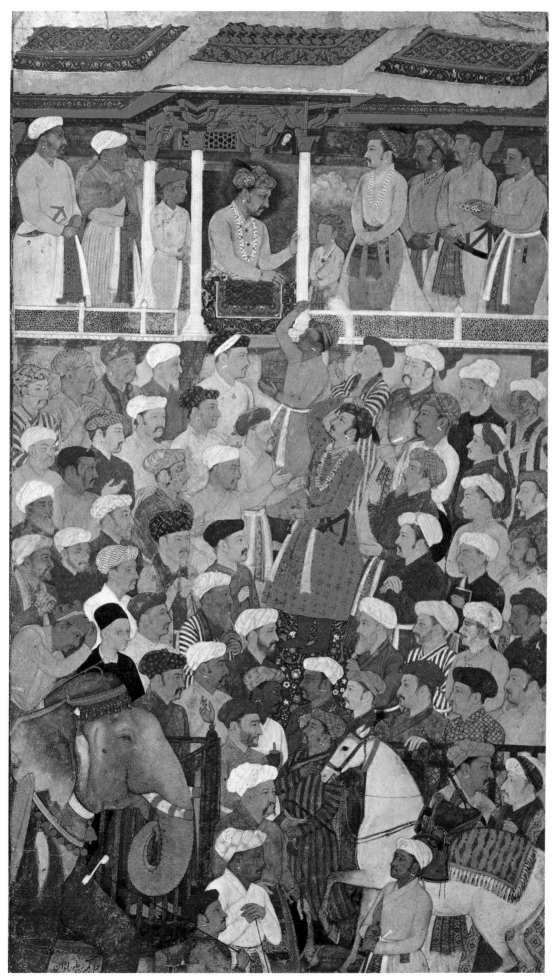

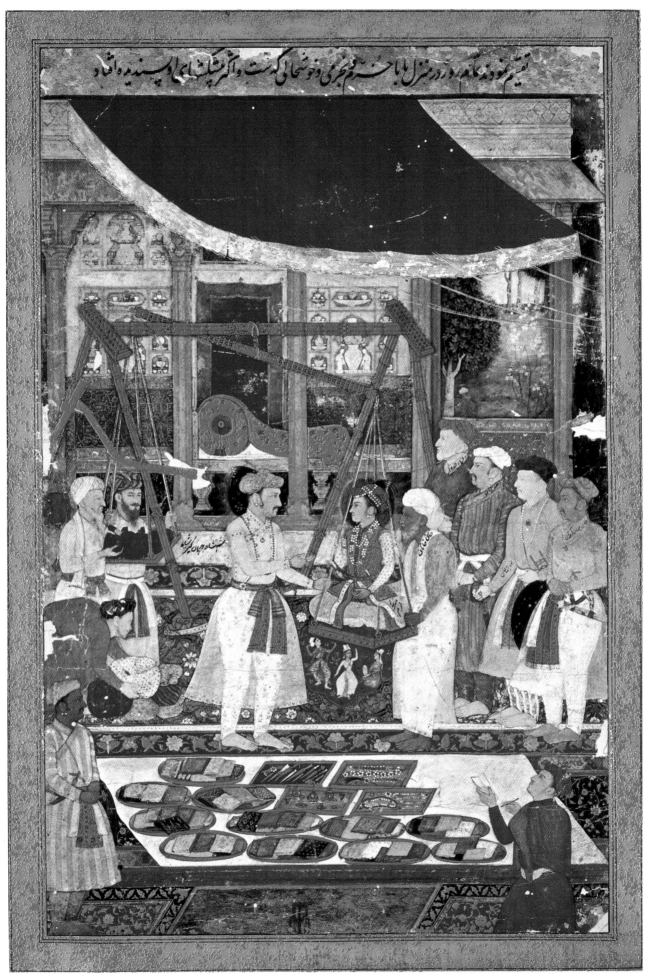

PLATE 18

Prince Khurram (later Shah Jahan) Weighed Against Metals

Jahangir described this episode, which took place in 1607, in his *Memoirs:*
"On Friday . . . I came to the quarters of Khurram which had been made
in the Urta Garden. In truth, the building is a delightful and well propor-
tioned one. Whereas it was the rule of my father to have himself weighed
twice every year, (once) according to the solar and (once according to the)
lunar year, and to have the princes weighed according to the solar year,
and moreover in this year, which was the commencement of my son Khur-
ram's sixteenth lunar year, the astrologers and astronomers represented that
a most important epoch according to his horoscope would occur, as the
prince's health had not been good, I gave an order that they should weigh
him according to the prescribed rule, against gold, silver, and other metals,
which should be divided among faqirs and the needy."

(*Memoirs,* vol I, p. 115.)

As so often in Mughal art, this miniature brings together the worlds of
flesh and spirit. While the setting is packed with rich carpets, jewels, im-
ported Chinese statuettes, and gem-studded weapons, the background opens
into a visionary garden.

PLATE 19

"Daulat the Painter and 'Abd al-Rahim the Scribe"

A true lover of books, pictures, and virtually all collectables, Jahangir never tired of their pleasures. Many manuscripts and miniatures are inscribed in his own hand with appreciative and discerning comments. A *Khamsa* of Nizami copied for Akbar by the eminent scribe 'Abd al-Rahim, known as *Ambar Qalam* ("Amber Pen"), was given a personal touch by Jahangir. He commissioned Daulat, one of his best painters, to add this portrait of himself painting the revered scribe to the colophon of the manuscript. Both men are shown with the materials of their trades in workaday attitudes. Daulat also adorned the borders of an album page dateable between 1609–14 with similar portrayals of Abu'l Hasan, Manohar, and Govardhan as well as another self-portrait (see Yedda Godard, "Les Marges du Murakka Gulshan," *Athar-e Iran,* tome 1, fasc. 1, Haarlem, 1936, pp. 11–33.) The album is now in the Gulistan Library, Teheran.

PLATE 20

A Thoughtful Man

Who was this serious but exquisite ponderer of life? Whether poet or philosopher, he strokes his beard in deep reflection. Despite his ease and grace of pose, the gentle elegance of his hands, and the idyllic setting of grass and flowers, his mood is disquieting. His forehead seems tense, with eyebrows raised over fearful eyes, and his sensitive lips are set in perturbation. Behind, a soaring aura of flame-like blossoms symbolizes his thoughts. But like his sumptuous closed book, and the rich assortment of flasks, cups, vases, and boxes—all containers of the unknown—their meaning is secret.

This brilliant, baffling jewel of a picture, a painted dance of broken curves, must once have adorned one of Jahangir's albums. His taste for foreign styles of art included Persian, European, and those of his neighboring rivals, the sultans of the Deccan. Here, the artist worked in a modified version of the Bijapur style, combining insightful Mughal characterization with markedly Persian color harmonies, a rhyme-scheme of repeated patterns, and a typically Bijapuri palette of golden-tan and rose-violet. Although Robert Skelton has attributed this picture to Farrukh Beg, an artist from Khurassan who worked for Akbar and Jahangir and visited the Deccan, the style is so like Muhammad 'Ali's, whose name is inscribed on the border, that we accept it as his.

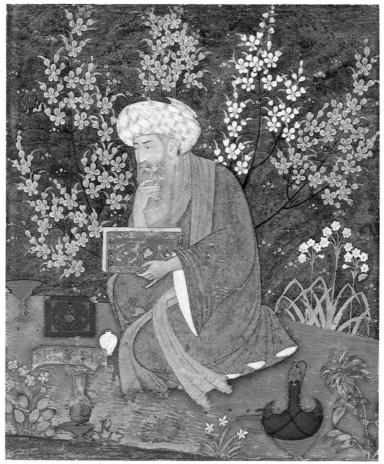

20

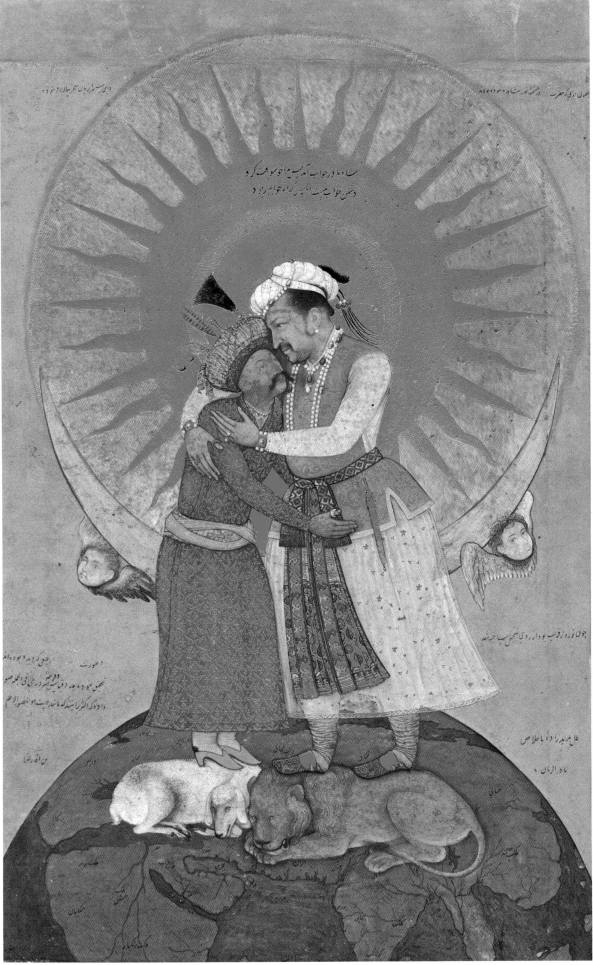

PLATE 21

Jahangir's Dream

Fretful over the possible loss to the Safavis of the strategic fortress of Qanda-
har, Jahangir had a dream of Shah 'Abbas Safavi appearing in a well of light
and making him happy. According to the inscriptions on this miniature, he
commissioned Abu'l Hasan to paint it.

Qandahar guarded the Mughals' vulnerable northwestern frontier and had
been contested by Safavis and Mughals ever since Humayun had failed to
return it to Shah Tahmasp (see Introduction). In 1613, Jahangir sent
Khan 'Alam as ambassador to Shah 'Abbas to plead the Mughal case. His
mission failed. The Persians took Qandahar in 1622 while Jahangir was too
preoccupied with Shah Jahan's rebellion to stop them.

Abu'l Hasan's portrait, according to an inscription, was based upon
inquiries—no doubt assisted by portraits from life by Bishndas, who accom-
panied the embassy. Eager to please his worried patron, Abu'l Hasan painted
a frail Shah 'Abbas with fashionably hennaed hands, cowering in the em-
brace of mighty Jahangir. Like the Hindu god Ganesh on his rodent vehicle,
the royal pair are borne by tactfully selected animals, which in turn rest
on a terrestrial globe. The Mughal strides on a powerful but peaceful lion
that has nudged the Shah's miserable sheep into the Mediterranean. Never-
theless, the Iranian has the good fortune to share Nur ud-din ("Light of
Religion") Jahangir's refulgent halo, the massed light of sun and moon,
supported by European-inspired angels.

PLATE 22

Jahangir Enthroned on an Hourglass

Haggard and resignedly gazing upwards, Jahangir offers a book to Shaikh Husain of the Chishti Shrine, a spiritual descendant of Shaikh Salim, to whom Akbar had gone prayerfully (and successfully) in the hope of an heir. The boon was granted, and at birth the prince, later Jahangir, was named Salim in gratitude to the saint.

In this allegory, painted almost a lifetime later, Jahangir sits on an hourglass throne. Although cupids have inscribed it with the wish that he might live a thousand years, the sands of time have almost run out. The Emperor is turning from this world to the next. The picture is inscribed, "Though outwardly shahs stand before him, he fixes his gazes on dervishes." He offers the book (of his life?) to the saint rather than to the earthbound standing by his curious throne: not to the Ottoman sultan (a generalized likeness based perhaps on a European print); nor to King James I of England (copied from an English miniature); and not even to Bichitr, a symbolic ruler of art, who painted himself holding a miniature showing two horses and an elephant—presents from his appreciative patron—and a deeply bowing self-portrait.

Like the hourglass throne, which may have been based on a small gilt-bronze and glass original, the idea of allegorical state portraits came from Europe, as did the cupids, who cover their eyes, either out of sadness for the aging emperor, or, more likely, for protection against the blinding radiance of his sun and moon halo.

Bichitr was a brilliant young follower of Abu'l Hasan who became one of Shah Jahan's leading court artists. Like Abu'l Hasan, he was prolific and all-encompassing, capable of painting everything from complex historical subjects to animals, highly inventive ornament, and sensitive individual portraits.

The verse quoted above was translated by Wheeler Thackston.

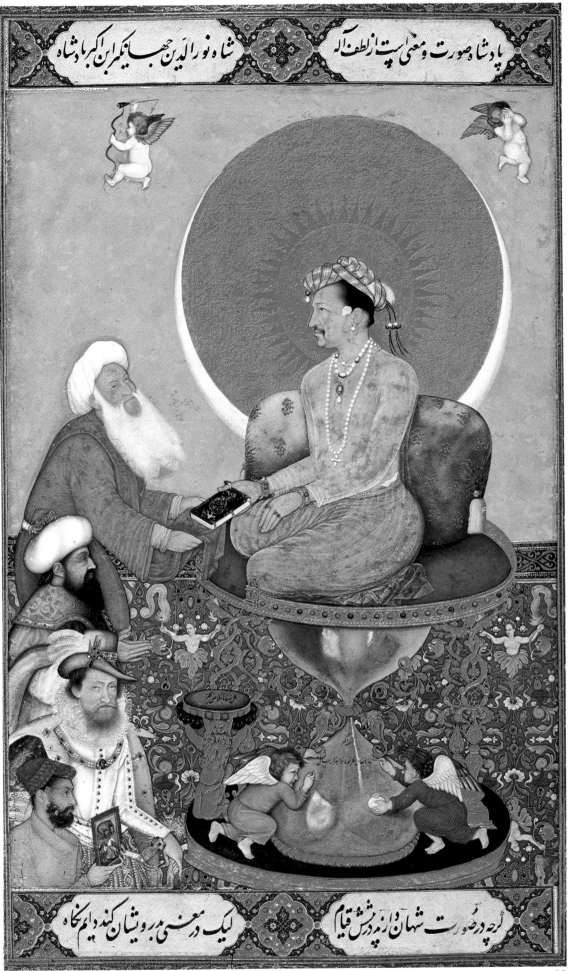

PLATE 23

'Inayat Khan Dying

Few civilizations confronted death as coolly as the Mughals. In his *Memoirs,* Jahangir wrote of this moving portrait:

"On this day news came of the death of 'Inayat Khan. He was one of my intimate attendants. As he was addicted to opium, and when he had the chance, to drinking as well, by degrees he became maddened with wine. As he was weakly built, he took more than he could digest, and was attacked by the disease of diarrhoea and in this weak state he two or three times fainted. By my order Hakim Rukna applied remedies, but whatever methods were resorted to gave no profit. At the same time a strange hunger came over him, and although the doctor exerted himself in order that he should not eat more than once in twenty-four hours, he could not restrain himself. He also would throw himself like a madman on water and fire until he fell into a bad state of body. At last, he became dropsical, and exceedingly low and weak. Some days before this, he had petitioned that he might go to Agra. I ordered him to come into my presence and obtain leave. They put him into a palanquin and brought him. He appeared so low and weak that I was astonished. 'He was skin drawn over bones' (verse) or rather his bones, too, had dissolved. Though painters have striven much in drawing an emaciated face, yet I have never seen anything like this, or even approaching to it. Good God, can a son of man come to such a shape and fashion?"

"As it was a very extraordinary case, I directed painters to take his portrait."

(*Memoirs,* vol. II, pp. 33–34)

This sad event took place in 1618.

It is enlightening to compare this painting to a preparatory sketch (Figure V). Although the drawing is more gripping in its uncompromising starkness, the painting is almost as moving. In it, some of our attention is directed away from the dying man to the arabesque carpet and pillows, one of which is large and dark, like a storm cloud descending.

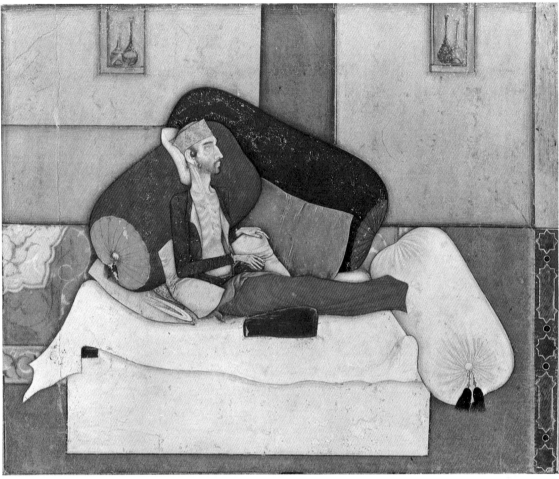

23

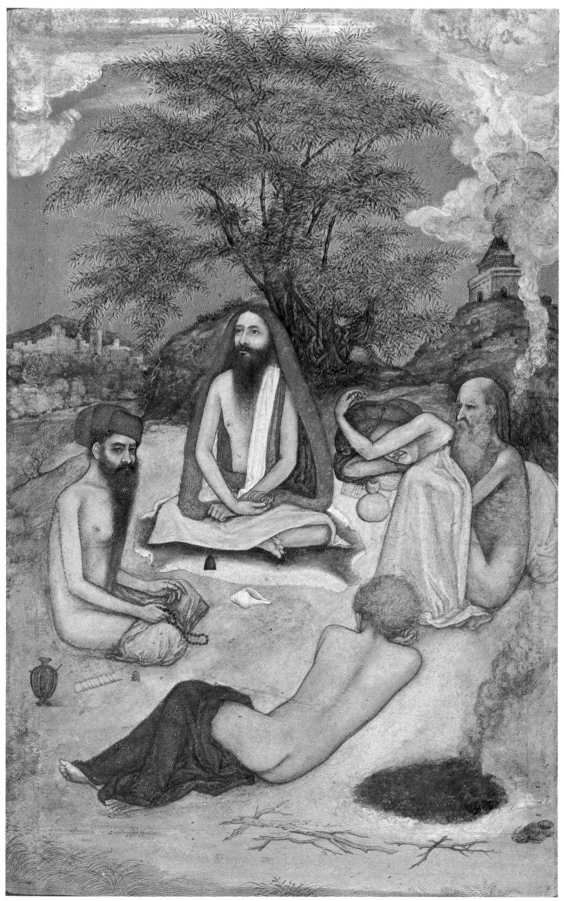

24

PLATE 24

Hindu Holy Men

In "spiritual darbar" five *sanyasis,* who have renounced the world, meditate beneath a neem tree, near a Hindu shrine close to Ajmer. The senior holy man, whose fingernails have grown into long coils, is elevated and illumined by deep concentration. His hair is very long and cultivated into a thick protective shawl. To his right, a seated ascetic whose hair has been shaped into a turban, recites *mantras* with a rosary of rudraksha seeds, while gazing toward the artist, or viewer. Opposite him, an old man, naked except for a light cloth over his knees and arms, looks ahead in profound distraction, while, behind him, a fourth reclines in troubled sleep. In the foreground, a *chela,* or apprentice, stretches out, totally naked except for a nubbly red cloth over his legs. His pose seems to have been inspired by a European mannerist print.

Although unsigned, this painting is certainly by Govardhan, who also painted Plate 28. His favorite palette is the golden-tan and gray one shown here, where it is keyed to the subject by the dung fire and the ashcovered figures. As an artist, he invites comparison to Basawan and Daulat, who shared his spiritually uplifting Rembrandtesque world of softly rounded, almost liquid forms and soulfully picturesque portraiture—rather than to Abu'l Hasan or Bichitr, who concentrated upon the richer, hard-edged, more brightly hued ambiance of imperial panoply.

PLATE 25

Squirrels in a Plane Tree

Why is the eager hunter climbing the tree? Does he really believe he can catch squirrels bare-handed? Or is he the artist's symbol of foolish, wicked man bent on destroying innocent nature? Knowing of Jahangir's interest in strange happenings, the man may indeed be a virtuoso of the chase. If the subject of the painting is baffling, its rank as a masterpiece of natural history picture is not.

Such subjects were favored in Mughal India. According to the *Memoirs* of Jouher, a servant of Humayun, a beautiful bird once flew into the imperial tent and "his Majesty . . . took a pair of scissors and cut some of the feathers off the animal; he sent for a painter, and had a picture taken of the bird, and afterwards ordered it to be released." (Jouher, *The Tezkereh al Vakiat*, tr. by Maj. Charles Stewart, Santiago de Compostella, Spain, N.D. p. 43.) While there are earlier examples of the genre, it was not until the reign of Jahangir that flora and fauna painting reached the degree of naturalism seen here, in which every beady eye, hungrily eager look, and springing tail is recorded with loving perfection.

The attribution of this picture is problematic, for an inscription on the back assigns it to "Abu'l Hasan, Nadir al-Asr," which combines Abu'l's name with the title of another artist, Mansur. Conceivably both worked on it, although the squirrels are so roundly treated and with such painterly, as opposed to draughtsmanly, qualities that we tend to see the squirrels as Abu'l Hasan's work.

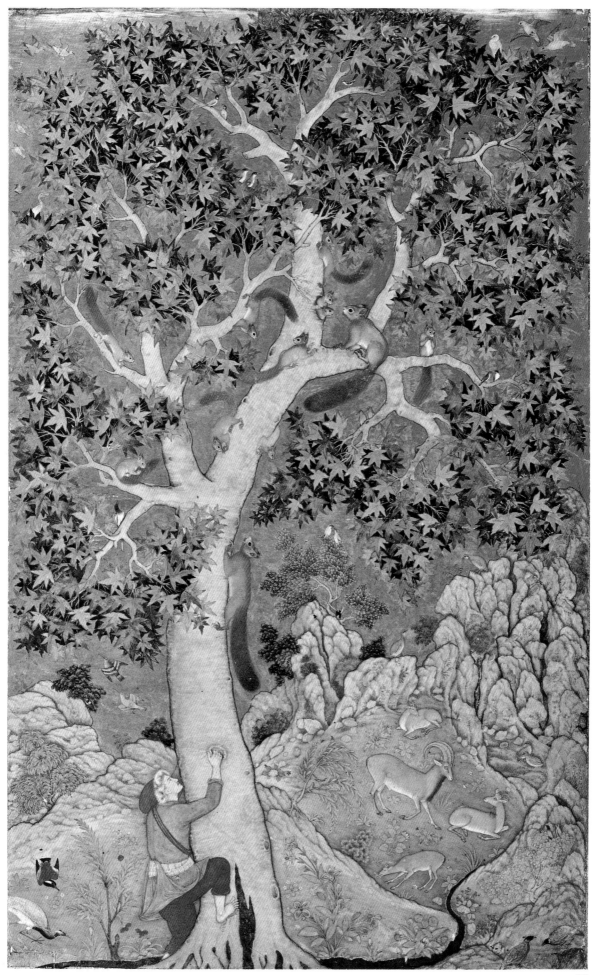

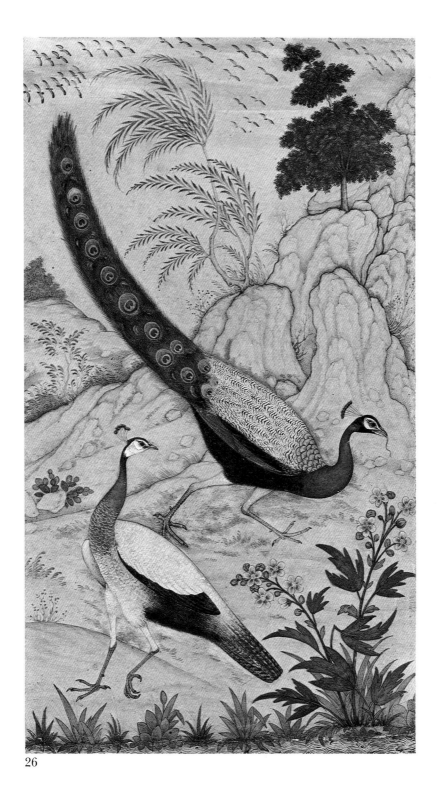

26

PLATE 26

Peafowl

The peacock rushes forward, intent upon the small snake in his beak. Excited, the hen twists her neck, eyeing the squirming morsel. Mansur, to whom this unsigned masterpiece has long been ascribed on grounds of style, must have started this picture from life, perhaps while crouched in a thicket, where he drew in the birds' elusive gestures. To catch every nuance of the peacock's sinewy rear leg, he sketched and resketched it, covering over his mistakes in white. The effect is spontaneous and convincing.

Later, in the workshop, he completed the picture, more concerned with artistic effects than naturalism. Inspired by the "eyes" of the tail feathers, he painted dazzling plumage, with golden highlights brilliant as fireworks. Piling on the richest lapis lazuli, he painted the bird's roundly feathered neck, modelling it with darker washes, and lending it iridescence with almost invisible strokes of vermilion.

The landscape, with its delightfully conventionalized trees and flowers, must also have been improvised in the studio. Distant hills and rocky cliffs, still faintly suggestive of hidden grotesques, recall earlier examples (Plates 2,5). The ornamentally patterned trees and flowers twist, turn, and soar in sympathy with the peafowl. Partly grounded in nature, partly fanciful, this miniature's total effect is wholly lyrical.

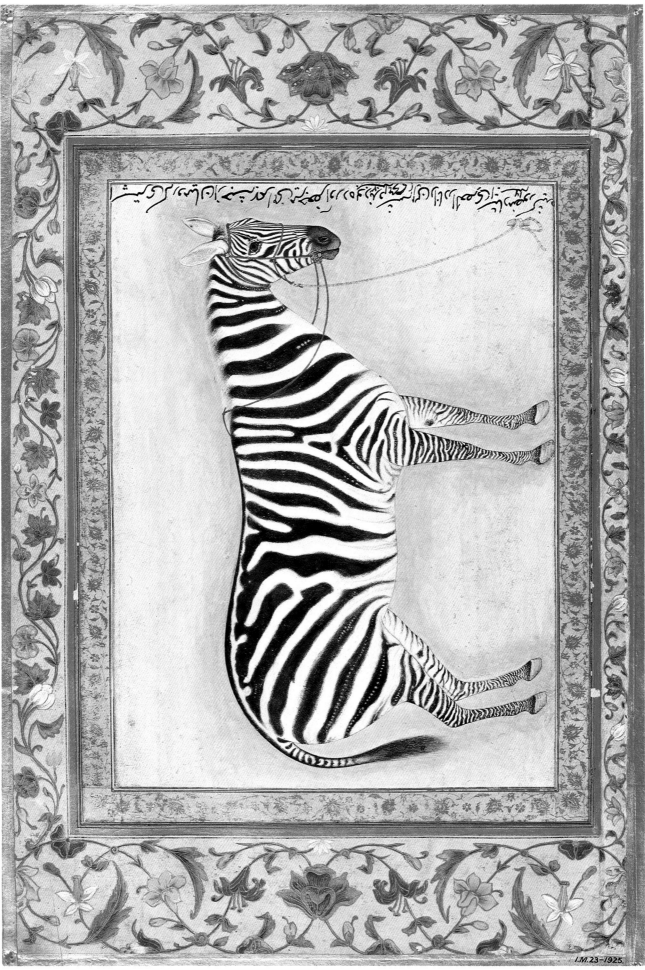

27

PLATE 27

A Zebra

When Jahangir was given this "exceedingly strange" animal, the first to reach his extensive zoo, he described it in his *Memoirs* (vol. II, p. 201). Because it was so odd, "some people imagined that it had been colored . . . (but) after minute inquiry into the truth, it became known that the lord of the world was the creator thereof." Later, "as it was a rarity, it was included among the royal gifts sent to my brother Shah 'Abbas" (Plate 21).

The painter is thus described in the *Memoirs*: "Ustad ("Master") Mansur has become such a master in painting that he has the title of Nadir al-'Asr, and in the art of drawing is unique in his generation. In the time of my father's reign and my own, these two (Abu'l Hasan and Mansur) have had no third." (*Memoirs*, vol. II, p. 20). Elsewhere in the *Memoirs* he mentions commissioning Mansur to paint a water-bird known as a *Saj* (*op. cit.*, p. 157), a falcon (*op. cit.* p. 108), and says that the artist has painted more than one hundred of the flowers of Kashmir (*op. cit.* p. 145).

When the emperor described this artist as unique "in the art of drawing" his words were carefully chosen; for surviving pictures by Mansur suggest that unlike Abu'l Hasan, who was a painterly artist, Mansur was a draughtsman whose pictures are invariably drawn and tinted rather than conceived and executed more coloristically.

The delightful border, a spiralling arabesque of vines and blossoms, was added to the painting before it was bound into one of the royal albums.

PLATE 28

A Rustic Concert

Leafing through Jahangir's or Shah Jahan's albums, one would have come upon folios of calligraphy by contemporary or earlier scribes, portraits of the royal family, miniatures removed from Persian or Mughal manuscripts, European prints, animal studies, and pictures such as this, showing musicians performing in the countryside. For the emperor, most of whose life was spent in the formal ambiance of the court, these genre subjects must have been refreshing, vicarious strolls into a more relaxed orbit.

Akbar had commissioned such subjects, the origin of which can be traced to the studies of servants in the *House of Timur* (Figure I). But European example further spurred Mughal artists in this direction, which was a specialty of Govardhan. This portrayal of musicians performing for a holy man, right, and his servant (?) is particularly indebted to Europe in the handling of a distant landscape. Paradoxically, this imported idea enabled Govardhan to paint one of the most Indian of scenes. Beyond the tents, the panorama includes thatch-roofed village houses, elephants, a horse cart, and many other nostalgic observations from life.

In discussing Plate 24, also by Govardhan, we have considered his characterizations in very general terms. Minor clues to his style are also helpful, such as his way of drawing thin, bony fingers, and edging folds of cloth with sinuous, wiggling outlines. He also liked to bring out fine details from broadly brushed areas of grays and tans.

PLATE 29

A Scribe

Intently copying lines from a larger manuscript to a smaller, this old calligrapher sat unselfconsciously for his likeness. His hands are crabbedly arthritic; his lean shoulders and elbows, pointed as arrows, jut out picturesquely, wearing thin his stiff, watered-silk coat. He has been hunched in this position for a lifetime, propped against a bolster as fat as he is lean. The toes of his right foot are calloused from rubbing against the silver and brocade pillow that balances his moving wrist and fingers. Next to him, a Chinese blue and white pot contains a day's supply of the lustrous black ink; he has already tracked gallons of it across countless reams of paper.

Lively pictures make us listen. This one is almost silent; we hear only the gentle scratching of a reed pen against paper, interrupted by an occasional dry cough. Like a perpetual motion machine, this old man writes on and on. But the happy, bouncing pattern of flowers in his carpet (a royal present?) is denied by the mysterious dark shadow of the open door.

The intensity of this portrait, with its uniquely foreshortened face and unusually thick pigment, suggests that the artist was strongly moved and feared that his revered friend might never pose again.

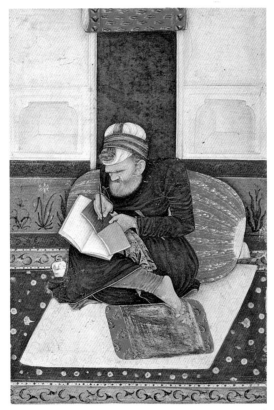

29

PLATE 30

Shamsa ("Sunburst")

This was the opening page to an album of calligraphies and miniatures assembled for Shah Jahan. Although he is chiefly remembered artistically as the builder of the Taj Mahal, the tomb of his wife, who died in childbirth after bearing him fourteen children, he was also a connoisseurly patron of painting. But unlike Jahangir, whose ideas on painting differed from those of his father, Shah Jahan encouraged artists to continue painting as they had for his father. His pictures, therefore, are sometimes difficult to differentiate from Jahangir's, although their colors tend to be more jewel-like, and their mood is usually more restrained.

A serious collector of gems, many of which he ordered set into his renowned Peacock Throne, Shah Jahan insisted upon opulent perfection in everything he commissioned. The workmanship and sumptuous color of this rosette by a specially trained illuminator rather than figure painter, as well as its nobly designed calligraphic inscription, bring together qualities of architecture, jewelry and painting. Indeed, this glorious design might be considered the embodiment of the verses inscribed in the emperor's Delhi Audience Hall, "If There is Heaven on Earth, it is here, it is here, it is here."

Such mathematically abstract and cerebral arabesque designs bring to mind the *Mandalas* of Buddhism and Hinduism, psychocosmograms designed for meditation. Here, the center of the composition can be interpreted as the pivot upon which all turns, the axis connecting the existential world with those above and below. It is no accident that Shah Jahan's titles are inscribed at the center of this heavenly image. As if to reinforce its celestial spirit, magnificent golden phoenixes, or simurghs, and other birds soar round the central figure.

PLATES 31–32

Shah Jahan Honors the Religious Orthodoxy

Like Akbar and Jahangir, Shah Jahan commissioned an official history of his reign. Although paintings were made for it over the years, it was assembled at the very end of his rule, and one can imagine him reliving happier days by turning its pages during the nine years of imprisonment in the Red Fort at Agra following Aurangzeb's seizure of the throne.

When it was assembled, a selection was made among the many pictures painted for the project. This double page and the battle scene of Plate 33 were omitted, perhaps because their subjects were adequately represented by other choices, and in due course they were separated from the manuscript. Persian floral borders signed by Muhammad Sadik and dated 1747 suggest that this audience scene (along with Plates 21 and 22) was in Iran by that time, presumably as part of the booty carried off by Nadir Shah at the sack of Delhi in 1739. The manuscript itself had reached Lucknow in the late eighteenth century, when it was presented to Lord Teignmouth "for deposit in the royal library" by the Nawab, Asaf ud-Daulah (1775–97), whose sack races of old women apparently pleased the Britisher less than the book.

PLATES 31–32 (Continued)

Although uninscribed, it can be surmised that this painting depicts a ban-
quet honoring Mullahs (theologians and specialists in religious law). Shah
Jahan is seated on the throne platform, with a shield adorned with birds of
paradise in front of him. Dara Shikoh, his eldest and favorite son, who was
usually kept nearby and was virtually promised the succession, sits just
behind his father. His youthful features are identical to another portrait, in
the Windsor manuscript, showing him being given jewelled necklaces by his
father at the time of his marriage in 1633 (folio 123v). Like this picture, it
can be attributed to Murad, to whom still another *Shah Jahan-nama* illustra-
tion (folio 193v) is attributed, with the statement that he was a pupil of
Nadir al-Zaman. It is known that of all Shah Jahan's sons, only Dara was per-
mitted to sit on the throne platform, and it seems likely that the Mullahs
were assembled on the occasion of the prince's marriage festivities.

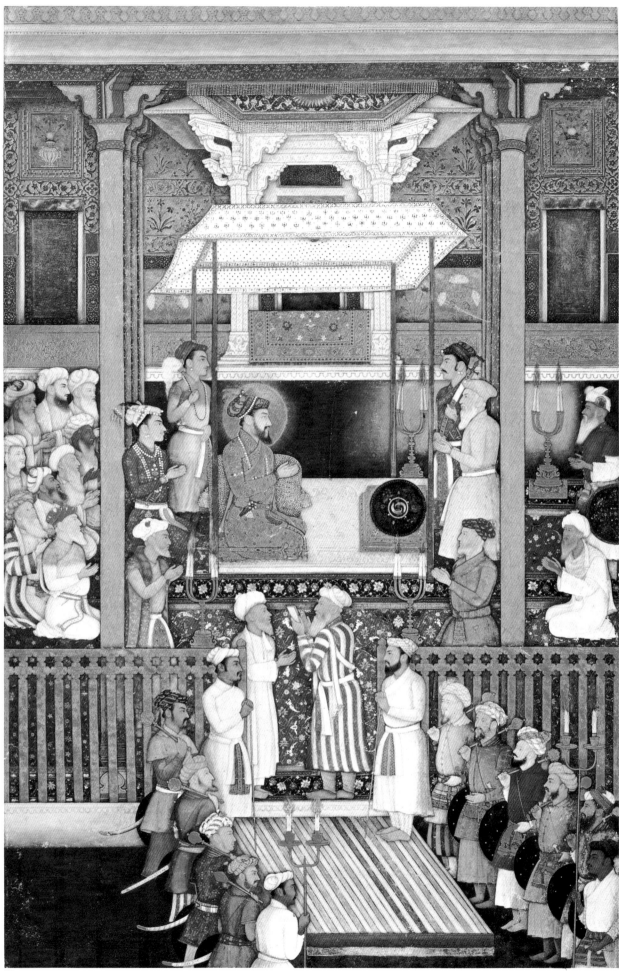

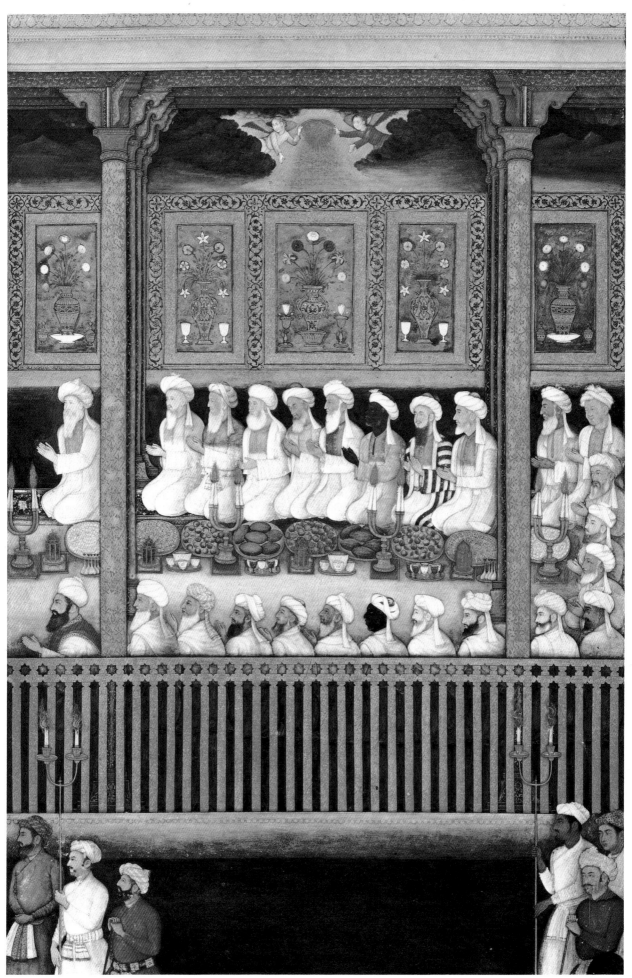

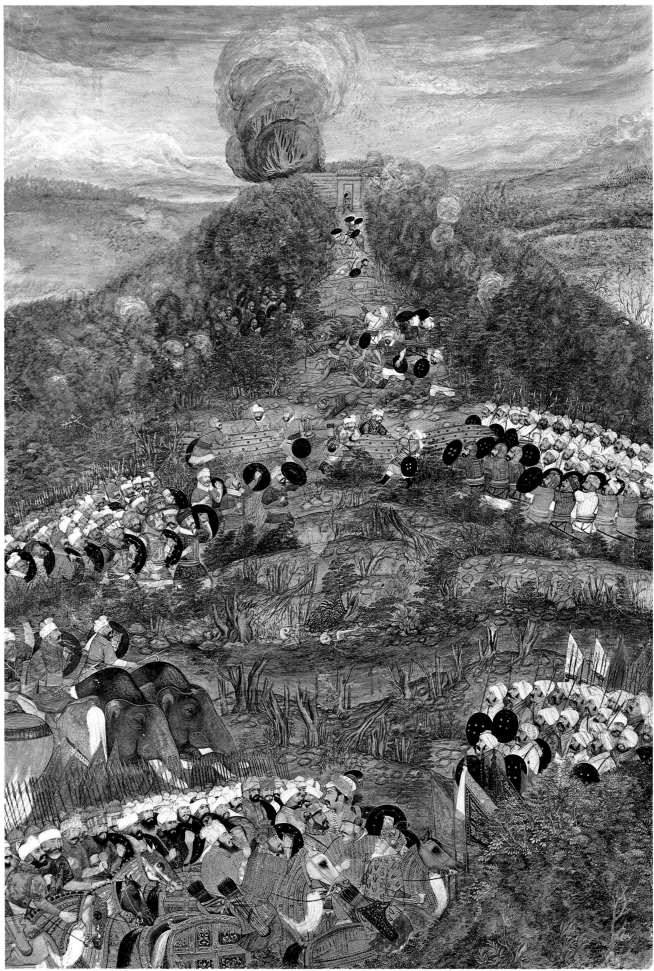

33

PLATE 33

An Incident at the Siege of Qandahar

As the favorite and eldest son of Shah Jahan, Dara Shikoh was appointed to lead a huge army to force the Safavi army from Qandahar, the strategic fortress defending the empire's northwest frontier. The campaign was not a success. In October of 1653, the prince retreated, after having scored few points against the Persians. One worthy of a painter's efforts was painted here. A lucky hit in the powder magazine of a small subsidiary fort brightened the sky with fireworks. Unfortunately, it also illumined the corpses and skeletons on the bleak, de-forested hill of battle, before which Dara Shikoh and his armies stand in proud rows.

Dara Shikoh preferred holy men, philosophers, and musicians to soldiers (Plate 36). His preparations for the siege verged on Quixoticism: as usual astrologers determined when to attack, but the spiritually elevated prince added a personal touch—a corps of holy men to augment mere military power. One of his warriors was a naked yogi, who was granted entry into the Safavi fort on the claim that he was a friend of the Mughal prince. Once inside, the harmless fellow was seized and ordered to work his magic against his own armies. When his spells failed, the poor fellow was tossed to his death off the fort walls.

Payag specialized in darkly romantic pictures: holy men by flickering candlelight, beneath moonlit cloudy skies, and battle scenes such as this, which evoke Altdorfer's painted visions. Here, as usual in his work, every infinitesimally small personage is an intriguing portrait.

PLATE 34

An Abyssinian from Ahmadnagar

Single figures, standing in isolation as though at court before the emperor, were a specialty of Mughal painters as early as the Akbar period (Figure IV). Here, Hashim has united power with elegance in a portrayal of a massive Abyssinian wearing the gold belt and pendants characteristic of Ahmadnagar, a rival power in the Deccan. His quick eye noted the twisted belt, strained by a pendulous melonate belly, the seams of the gusseted transparent shirt, and the pinkish fingers holding a superb Deccani sword. In contrast to the subject's massive arms and steatopygous bulk, Hashim invented a subtly lyrical color harmony of whites, off-whites, and duck-egg blue, accented by deep brown skin, gold, richer blues in the sheath and scabbard, and vermilion shoes. The discolorations in the background are due to the artist's final touches, using a mixture of pigments that included a khaki which darkens in time.

The portrait somewhat resembles Malik Ambar, the proud and able Abyssinian statesman whose generalship was largely responsible for the successful Deccani resistance to the Mughals before he died at eighty in 1626. It probably portrays his son, Fath Khan, who yielded the important fort of Daulatabad to the Mughals, after a three and one half month siege in 1633. He was invited to court, where this portrait was probably painted, and allowed by Shah Jahan to retire to Lahore with a generous allowance.

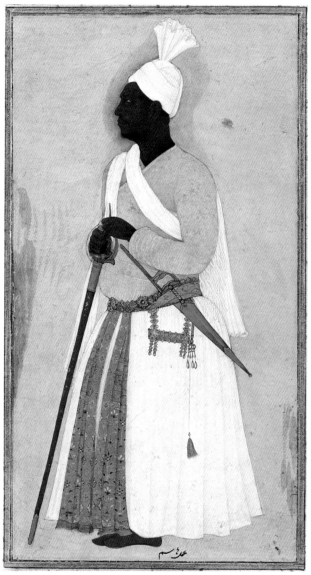

عمل سم

34

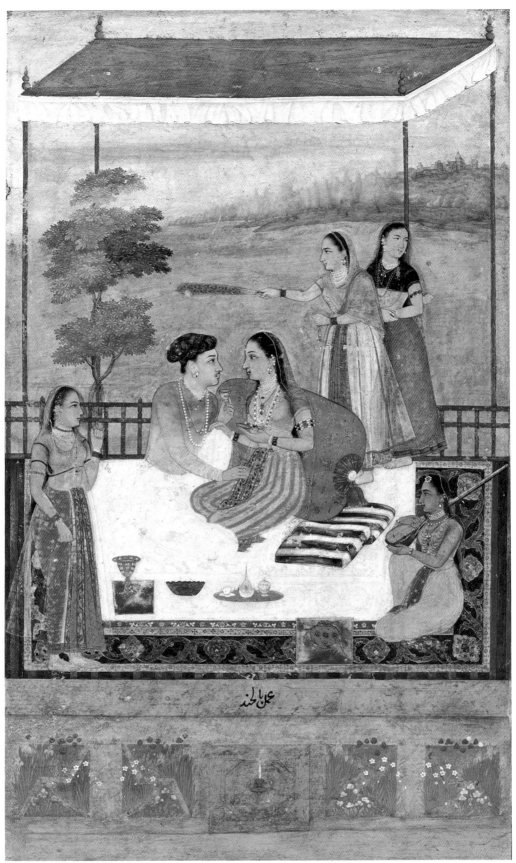

35

PLATE 35

Royal Lovers on a Terrace

Gazing deeply into one another's eyes, and attended by tactful servant girls and a musician, a loving couple enjoys the cool of dusk, a favorite time in India. The prince is Shah Shuja, second son of Shah Jahan, who was born in 1616 at Ajmer. In 1633, he married the daughter of Mirza Rustam Safavi, a great courtier and wit who was related to the royal house of Iran. As a child, Shah Shuja was loved by Nur Jahan and his grandfather, Jahangir, near whom he stands in Plate 17. He grew up pampered at the imperial court, but while he was a beautiful child, portraits of him at fifteen in the *Shah Jahan-nama* and elsewhere look prematurely middle-aged.

In this portrait, which must have been painted at the time of the prince's marriage, Bal Chand emphasized the couple's inner sweetness at a tender moment. Underscoring their physical shortcomings, it is one of the most movingly romantic of Mughal miniatures. As usual in his courtly style, Bal Chand balances the gem-like hardness of textile patterns, wine cups, and symbolically interwoven trees with soft passages, such as the gently moving river and distant architecture. Like the Taj Mahal, this picture celebrates the purity of white, as in the subtle placing of the prince's white shirt and pajameh against a carpet of white arabesque. In the foreground, freely scattered white flowers counterpoint the geometry of rectangles and auspicious swastikas. Unwilling to mar his picture with disturbing realities, the artist chopped off two of the four poles supporting the canopy.

Although intelligent, active, and effective by nature, Shah Shuja was softened by life in Bengal, where he was appointed governor in 1639. He was no match for his younger brother Aurangzeb in the wars of succession that began during Shah Jahan's illness in 1657. In 1659, Aurangzeb defeated Shah Shuja at the battle of Khajwa, near Allahabad. With his family, he fled to Bengal, and sought refuge in Arakan. Some claim that he was murdered there, after which his wife and daughters committed suicide.

PLATE 36

Dara Shikoh with Sages in a Garden

To prevent a repetition of his own and his father's rebellions against imperial parents, the emperor kept Dara close to the throne. In consequence, he was able to pursue artistic and theological interests. Like Akbar, he was fascinated by Hinduism and he translated Hindu texts, discoursed with holy men, and may well have been the patron of portraits of them (Plate 24).

Regrettably, these peaceful activities were poor preparation for war. As we have seen, Qandahar could not be captured by spiritual force. Moreover, his religious tolerance, so similar to Akbar's, was at odds with prevailing attitudes. In the wars of succession, Dara was hopelessly outmatched by Aurangzeb, his orthodox and militant younger brother. After two defeats in battle, he was hunted down by Aurangzeb's armies and betrayed by a nobleman whose life he had once saved. In the Delhi streets, he was forced to sit backward on an elephant and to be pelted with offal by hooligans. But more citizens shed tears than reviled him, and Dara's popularity threatened Aurangzeb's throne. After a trial for heresy, Dara Shikoh was executed in his jail cell, before the eyes of a favorite son. When his bleeding head was brought, Aurangzeb wept.

Bichitr painted the prince with learned and talented friends at the height of his power, when poetry, music, and serious conversation were his chief concerns. The prince and his guests are eminently aristocratic. The setting verges on paradise: a garden fragrant with flowers and a platform covered with superb carpets. A servant offers wine, others await attentively, and in the distance a bed is prepared for Dara's rest after the party. Bichitr describes all this with his usual masterfulness, delighting in such passages as the reflections on glass, transparency of wine, and cast shadows. The curving fingers of the soldier in the foreground are a minor but telling clue to his style.

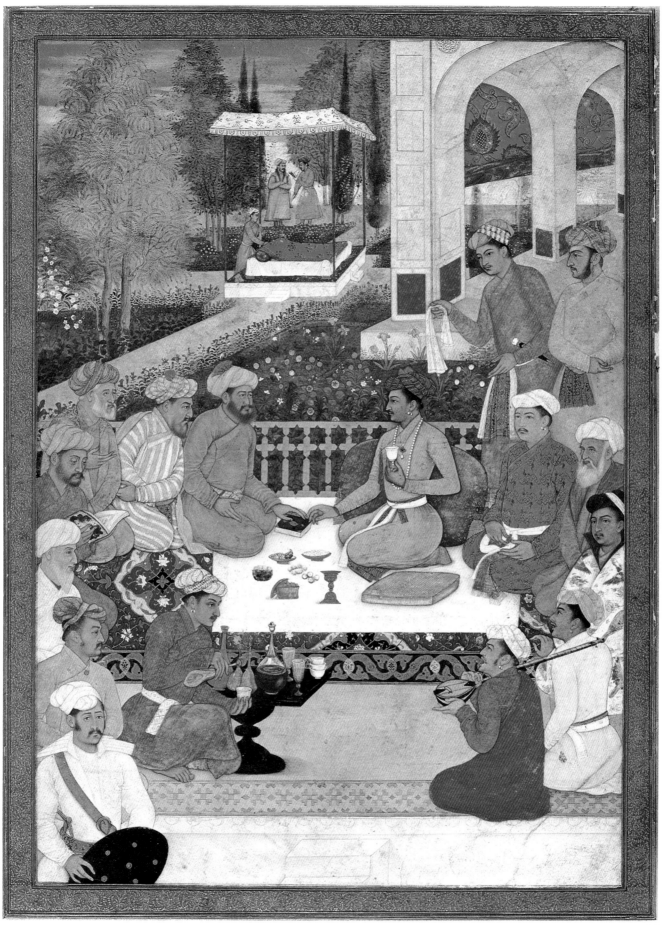

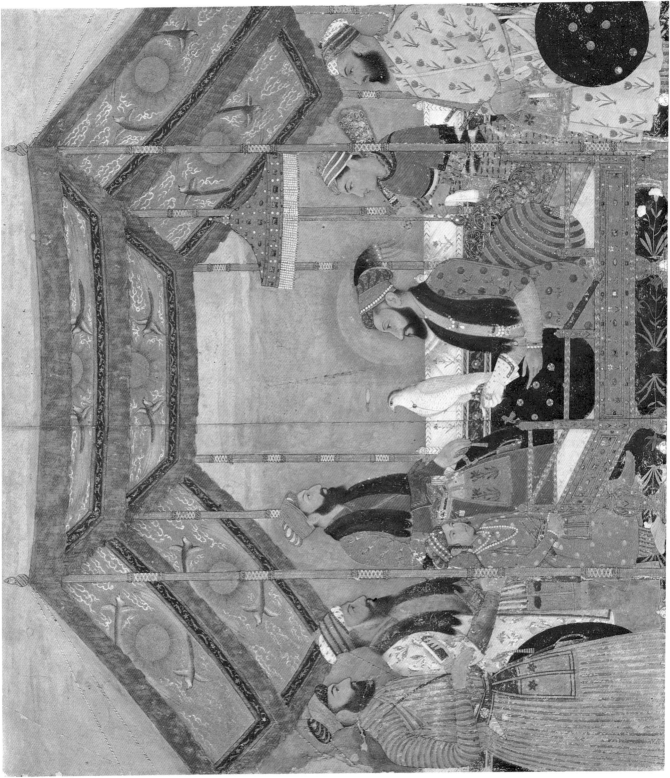

PLATE 37

Darbar of 'Alamgir

Shah Jahan's third son, Aurangzeb, took the title of 'Alamgir ("Seizer of the Universe") when he assumed the throne after imprisoning his father in 1658. Although he was the mightiest of Mughals, he was also the most destructive to the empire. Despite his religious piety, frequent thoughtfulness on a personal level, and machine-like industry, his policies tore down what his great-grandfather had built. While Akbar had fostered unity between Muslims and Hindus, 'Alamgir's zealous Sunni orthodoxy alienated most Hindus, including the soldierly Rajputs, whose arms had contributed so essentially to the formation and maintenance of the empire. By over-expansion in conquering the Deccan, his empire became unwieldy. The later decades of his long reign were spent trying to stamp out rebellions. Sadly, before his death at ninety, 'Alamgir was aware of many of his grim follies.

In spite of his later austerity, which turned him against music, dance, and painting, a few of the best Mughal paintings were made for 'Alamgir. Perhaps the painters realized that he might close the workshops and therefore exceeded themselves in his behalf. For whatever reason, this darbar is of stunning quality. The awesomely dignified emperor holds a hawk, while seated on an elegantly unpretentious gold throne beneath a canopy adorned with birds of paradise. His third son, Muhammad A'zam, who was born in 1653, stands facing him, looking very boyish and lively in contrast to the formality of the others. The black-bearded dignitary to his left is Shaisteh Khan, son of Nur Jahan's brother 'Asaf Khan.

Probably painted for an album, this miniature might be by Bichitr.

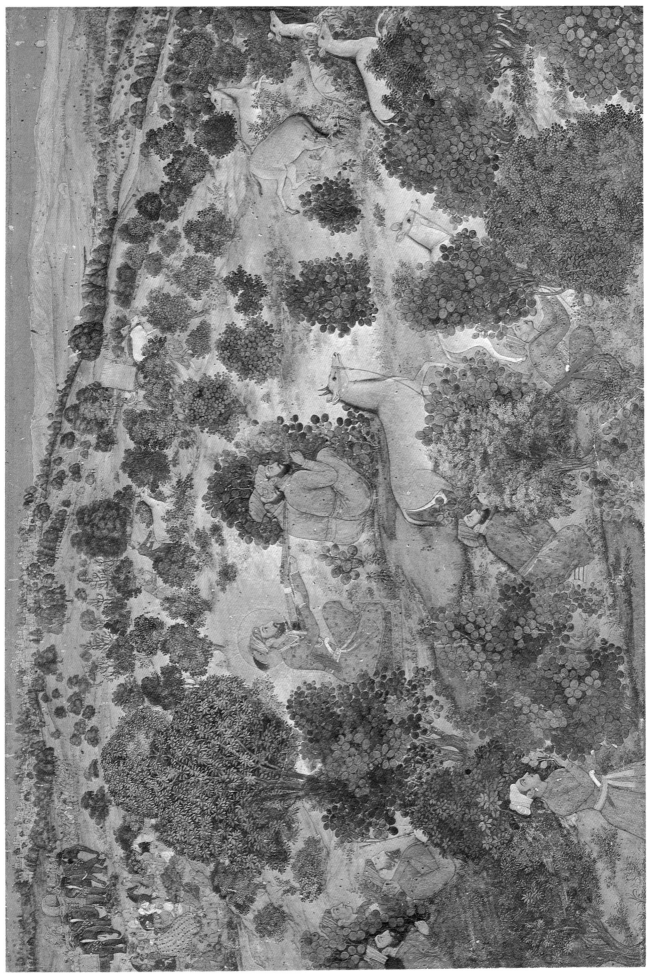

38

PLATE 38

'Alamgir Hunting Nilgai

This large hunting scene can hardly be bettered in seventeenth-century Mughal art, even though it was painted for the austere 'Alamgir, who virtually closed down the royal workshops a few years after he came to the throne. It was probably painted by Bichitr, the major master who had worked for Jahangir and Shah Jahan (Plates 22, 36), whose signature is on a smaller but stylistically identical picture in the Custodia Foundation, Paris.

Dressed in hunting green (even his halo is camouflaged), the emperor sits on a small carpet behind two attendants who support his matchlock, whose fuse has burned to the end and fired its charge. Shot in the heart, the nilgai (literally "blue cow," although related to the deer) tumbles dead, a victim of the decoy staked near a water-hole and imperial marksmanship. A scrubby landscape stretches into low hills and distant cliffs across the picture, which includes a city on the horizon. Nearer by, 'Alamgir's state elephants, one with a golden howdah, reveal the lavishness of his hunting expedition. Wherever we look, beaters, huntsman, courtiers, and other attendants dot the vast field.

However much 'Alamgir enjoyed such entertainments early in his reign when this picture must have been painted, he soon became too preoccupied with matters of state for such indulgences. Alas, instead of enjoying imperial prerogatives, he spent most of his reign in serious pursuits, such as conquering the Deccan, a triumph that brought the empire to its peak of size but also made it unwieldy. The later decades of 'Alamgir's life were all spent in the Deccan, stamping out rebellions.

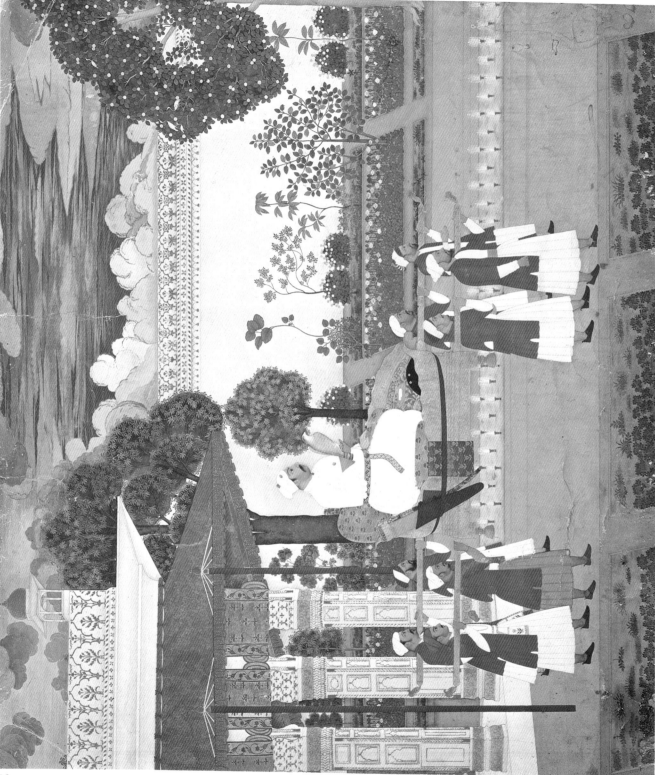

39

PLATE 39

Muhammad Shah Viewing a Garden

Nicknamed *Rangila* ("Pleasure Lover"), Muhammad Shah attempted at first to bring stability to the crumbling empire, a hopeless task. Eager for easy riches, Nadir Shah the Persian invaded Hindustan in 1739, sacked Delhi, and left. Unwilling to serve the empire, Muhammad Shah's ablest and most powerful nobles set up independent states at Oudh, in Bengal, and in the Deccan, where the Nizams of Hyderabad held sway. Once, when a Nizam visited Delhi, the emperor achieved a moment of revenge. On a very hot day, an imperial emissary interrupted the Nizam's noon nap with an urgent invitation to come to the Jama Masjid (Shah Jahan's mosque). There, standing in the broiling sun, the emperor greeted his guest, and kept him standing, bare feet on burning stone, until the poor fellow danced with pain.

Most of the time, however, Muhammad Shah cultivated the arts: music, gardening, dance, and painting. His artists' work is unmistakable, with its crisp, bright palette, dazzling red-orange and gold skies, and deliberately un-intimate portraiture. At best, as here, his pictures are thinly painted late flowerings from a slowly dying tradition. But such passages as the flowers and leaves silhouetted against white are sensitive and genuinely moving. Mughal culture long survived its political failure.

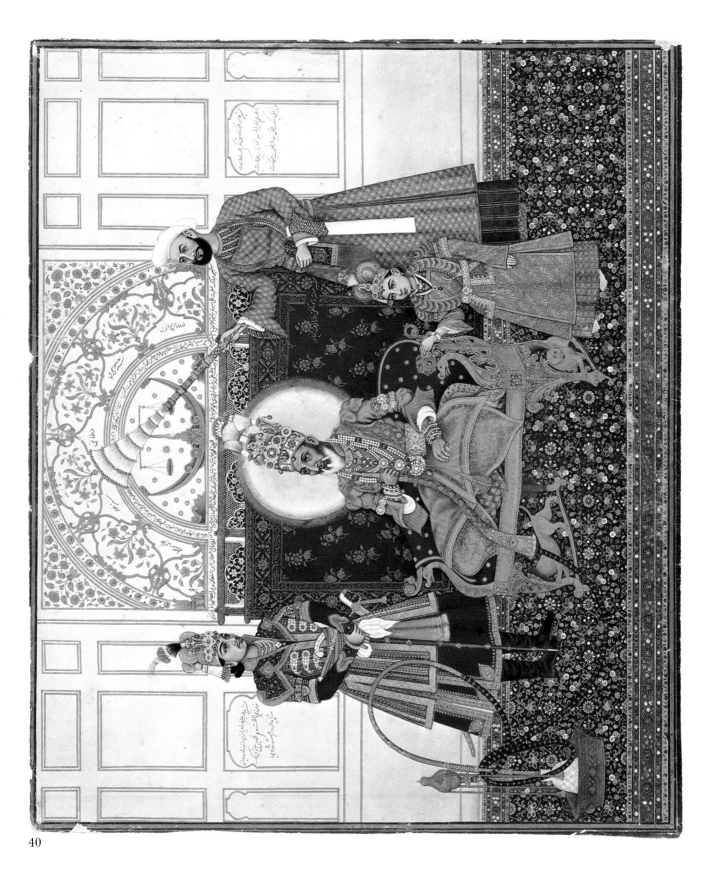

40

PLATE 40

Bahadur Shah II

The inscription reads, in part: "An auspicious likeness of His Majesty the Shadow of God . . . exalted King of Kings . . . Prince Shadow of God, Refuge of Islam, Propagator of the Muhammadan Religion, Increasor of the Splendour of the Community of the Paraclete, Progeny of the Gurganid (Mughal) Dynasty, Choicest of the Race of the Sahibqiran (Tamerlane), exhalted King of Kings, Emperor and son of Emperor, Sultan and son of Sultan, Possessed of Glories and Victories." (translated by Wheeler Thackston)

A talented poet, Bahadur Shah II might also have been a great ruler; but his reign was a tragicomedy of overblown titles and tinsel grandeur. An aspiring prince once tried to poison him with a tiger's whisker. Although a puppet of the British most of his reign, in 1857 he was coerced into nominally leading the Sepoy Rebellion, which ended with most of his sons shot dead and Bahadur Shah himself put to trial. According to Delhi tradition, on his arrest a favorite elephant, Maula Bakhsh, was in *mast* (heat). On regaining his senses, the animal roamed the Delhi streets searching for his master. The elephant's vast corpse was found in Ferozshah Kotla. Bahadur Shah was exiled to Burma, where his few remaining years were spent writing sad verse.

My heart finds no love in a realm so desolate.
Whose bride is found in a world so inconstant?

From a long life's wish, but four days were granted:
Two were spent in desire, two elapsed in longing.

Say if you will: Live apart from this place of yearnings.
But where is there such space in a seared heart?

How star-crossed is Zafar, that for his grave
He found not even two yards of ground in the lane of the Beloved.

(A ghazal written by the emperor, whose poetical name was Zafar, before his death in exile. Translated by Brian Silver.)